# PADDLE NORTH

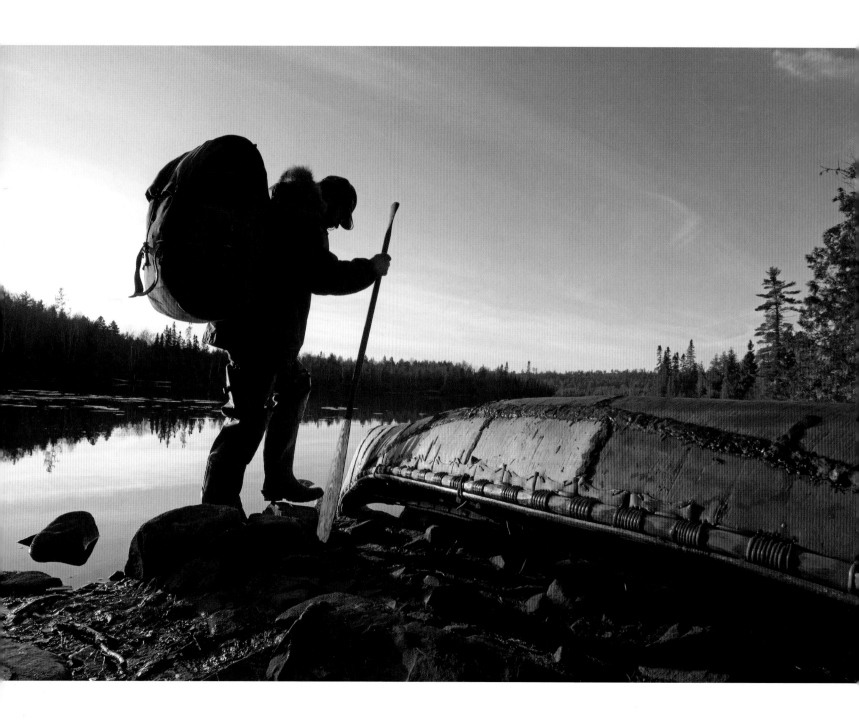

*photographs* » **LAYNE KENNEDY**     **GREG BREINING** « *essays*

# PADDLE NORTH

*Canoeing the* **BOUNDARY WATERS–QUETICO** *Wilderness*

MINNESOTA HISTORICAL SOCIETY PRESS

www.mhspress.org

The Minnesota Historical Society Press is a member of the Association of American University Presses.

Book and jacket design: Susan Kaneko Binkley/Breeze Publishing Arts

Manufactured in China by Pettit Network Inc., Afton, MN

10 9 8 7 6 5 4 3 2 1

♻ The paper used in this publication meets the minimum requirements of the American National Standard for Information Sciences—Permanence for Printed Library Materials, ANSI Z39.48–1984.

International Standard Book Number
ISBN-13: 978-0-87351-778-2 (cloth)

Library of Congress Cataloging-in-Publication Data
Kennedy, Layne, 1957–
    Paddle north : canoeing the Boundary Waters–Quetico Wilderness / photographs by Layne Kennedy ; essays by Greg Breining.
        p. cm.
        Includes index.
        ISBN 978-0-87351-778-2 (cloth : alk. paper)
    1. Canoes and canoeing—Minnesota—Boundary Waters Canoe Area—Pictorial works. 2. Canoes and canoeing—Minnesota—Boundary Waters Canoe Area. 3. Boundary Waters Canoe Area (Minn.)—Pictorial works. 4. Boundary Waters Canoe Area (Minn.)—Description and travel. 5. Canoes and canoeing—Ontario—Quetico Provincial Park—Pictorial works. 6. Canoes and canoeing—Ontario—Quetico Provincial Park. 7. Quetico Provincial Park (Ont.)—Pictorial works. 8. Quetico Provincial Park (Ont.)—Description and travel. I. Breining, Greg. II. Title.
    GV776.M62B6845 2010
    797.1´2209776—dc22                                                                  2010014993

Images on pages 13 (middle), 20, 28 (middle), and 121 (right) from Minnesota Historical Society collections.

# ⁓ CONTENTS

1    Chapter I      Northern Light

9    Chapter II     The Dream of a Canoe

23   Chapter III    A Map in the Mind

35   Chapter IV     Bones of the Earth

51   Chapter V      The Portage

65   Chapter VI     An Imaginary Line

79   Chapter VII    Forest Primeval

95   Chapter VIII   Winter Trials

107  Chapter IX     Shadows of the North

119  Chapter X      Listening Point

132  *Author's Note*

134  *Photographer's Note*

136  *Index*

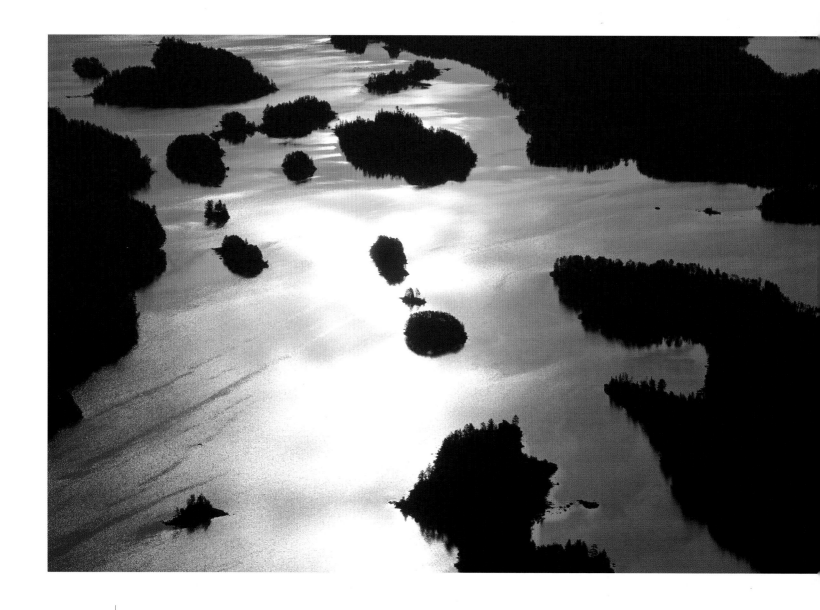

INFINITE WATERWAYS. *Aerial photograph of Burntside Lake, located next to the Boundary Waters Canoe Area Wilderness*

# I ❦ NORTHERN LIGHT

ALONE ON OUR OWN TINY ISLAND, my wife, Susan, and I watched the sun set on Beaverhouse Lake. A sliver moon dressed the silhouette of a granite island draped in spruce. A loon called, the sound echoing off the far shore and dying

somewhere in the distance. We sat on a long outcrop, gnarlier and broader than a whale, where only lichens, mosses, and tufts of grass found a foothold.

People call this canoe country, the Boundary Waters, the Quetico-Superior. It is a vast tangle of rock-ribbed waterways that sits on the border between Minnesota and Ontario. Beaverhouse Lake lies in Canada's Quetico Provincial Park, but we could as easily be watching the sun set in Minnesota's Boundary Waters Canoe Area Wilderness south of the border. Or just to the west in Voyageurs National Park.

Sitting on these old bones of the earth, we could see the ocean. Not literally, granted, but here at our feet were threads of water that knit together the continent, from sea to sea. Big lakes reach to the horizon, their points and bluffs receding, layer upon layer, a series of veils, each paler than the one before,

until they disappear into the distance. Bogs and creeks ebb and flow, feeding streams and joining rivers that thunder through rapids and spill down falls. Given time and supplies, we could launch our canoe and follow the setting sun to the Arctic Ocean. Or wait till morning and chase the sunrise to the Atlantic.

Susan and I had reached the end of a long trip, a challenging one—daily rain and the worst mosquitoes we had ever experienced. We had somehow brought only a single sleeping bag. Yet we camped in comfort and enjoyed the trip more than we had a right to. Tonight was perhaps our best camp yet. For the day we were able to claim our very own island. Our kitchen sat snug beneath a tarp; a flat rock served as our table. Though I failed to catch a walleye for dinner, Susan had just cooked bannock packed with blueberries she had picked around our tent.

I first began coming up here more than forty years ago. With age, I've developed more wilderness skills, found more confidence, and discovered more joy than ever in the solitude of this country and simple acts of camping and traveling on these lakes.

Susan and I felt alone on these rocks, but we weren't, of course. Far from it. Now, at the height of summer, thousands like us had come to canoe country in vehicles bulging with camping gear and topped by a canoe or two. Yet somehow this crowd had vanished into the wilderness just as water drains into sand—a quarter of a million people disappearing each year into more than two million acres, an area the size of Delaware and Rhode Island combined.

Why do we come? What makes this land so special? It is like few other places on earth. Some symbols of this wilderness are tangible and solid—exposures of bedrock, expanses of water, forests of conifers, aspen, and birch. Other associations—the smell of dampness on a portage between lakes, the light in the rain on a lake filled with craggy islands, or the silent glide of a canoe on calm water—are so fleeting they defy description. More abstract are questions I have

EVENING CAMPFIRE, *Lake Agnes, Boundary Waters*

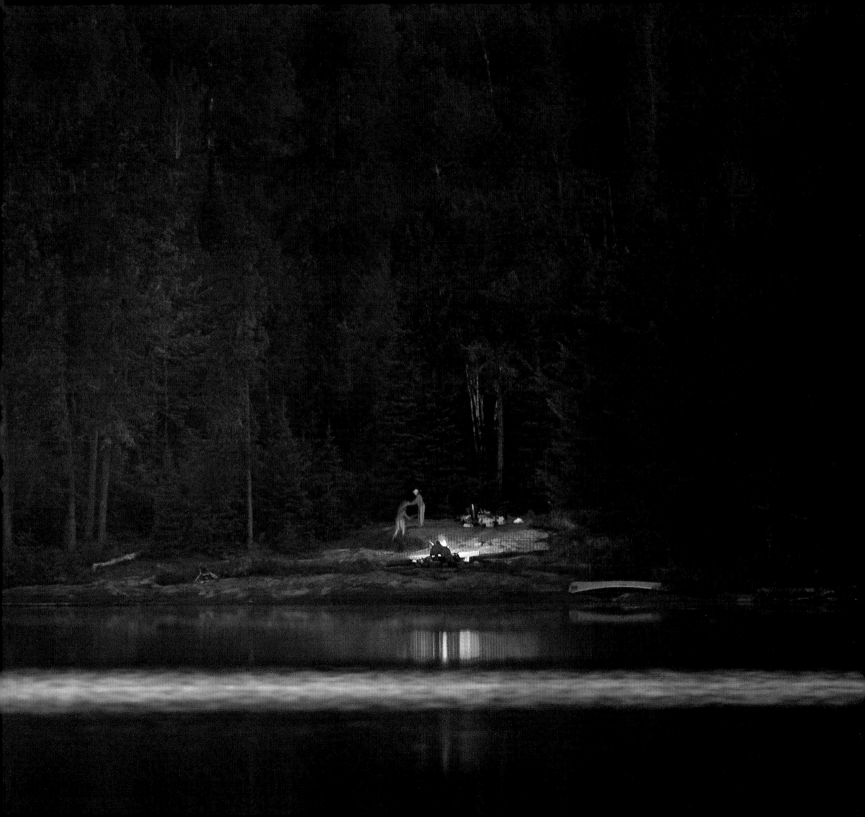

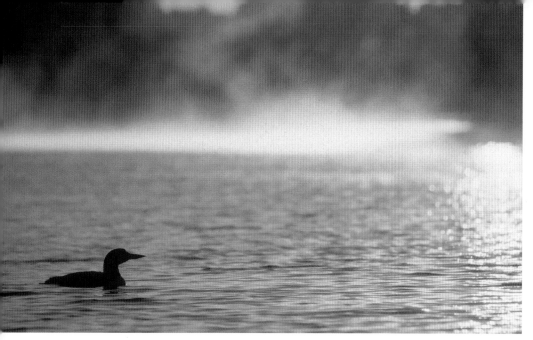

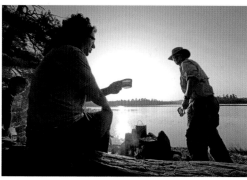

**MORNING TIME IN CANOE COUNTRY.** *Common loon, Gneiss Lake; ripening blueberries; campfire breakfast on Nina Moose Lake; camp utensils, including marshmallow sticks*

about the nature of wilderness, the proper relationship between man and nature, and whether it even makes sense today to talk about wilderness apart from human husbandry. I've come here many times to both enjoy and better understand these things.

Susan and I lingered on our whale-rock. We watched the deepening colors in the west fade to pinpricks of starlight, reluctant to call an end to our last night in the forest. These campsites, these lakes, and these images are like the people you meet on a long trip—you may renew the acquaintance on some occasion, but more likely you part never to return. This day and our time here will become no more than memory.

Tomorrow we will rise, finish our bannock, strike our camp, and set out early, mindful that a rising wind across the broad fetch of Beaverhouse Lake could leave us trapped—if you could use such a word for a place such as this.

## canoe country—a comparison

### Boundary Waters Canoe Area Wilderness

‣ Established as part of newly created Superior National Forest in 1909 and managed today by the U.S. Forest Service as wilderness

‣ 1,098,057 acres

‣ 1,026 lakes larger than ten acres

‣ Motor use allowed on eighteen lakes

‣ Nearly 2,200 designated campsites

‣ A permit and quota system distributes more than 250,000 visitors a year to nearly a hundred entry points on the perimeter of the wilderness.

---

### Quetico Provincial Park

‣ Established as a forest and game reserve in 1909. Ontario Parks manages nearly the entire area as wilderness.

‣ 1,175,683 acres (475,782 hectares)

‣ 678 lakes larger than ten hectares (The difference in the minimum size of a countable "lake"—ten hectares is 24.7 acres—makes a direct comparison to the Boundary Waters difficult.)

‣ By cooperative agreement, members of the Lac la Croix Guides Association can use small motorboats on twenty-one designated lakes (one of which can be selected each year as fly-in).

‣ More than 2,000 primitive campsites, marked by fire rings but no grates or signs

‣ Of approximately 18,000 visitors who canoe and camp in the interior each year, about 90 percent come from the United States.

‣ A permit and quota system directs canoeists to twenty-two entry points.

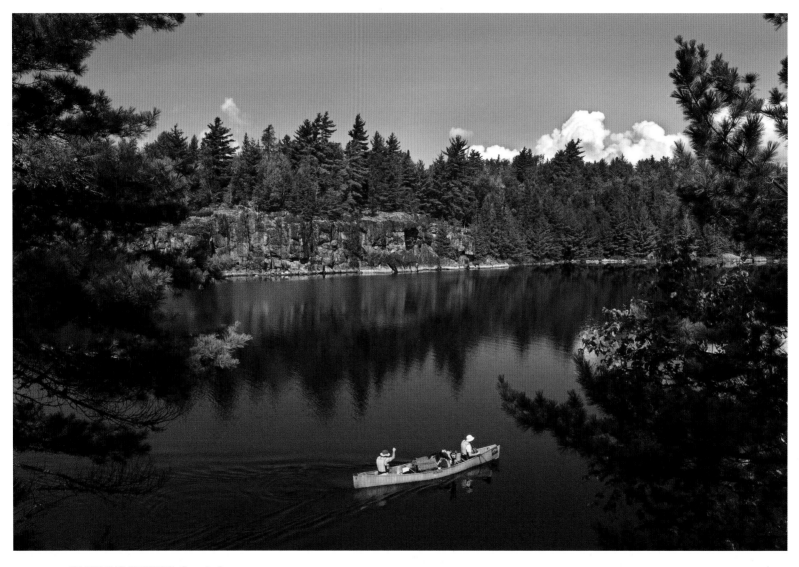

PADDLING QUETICO, *Grey Lake*

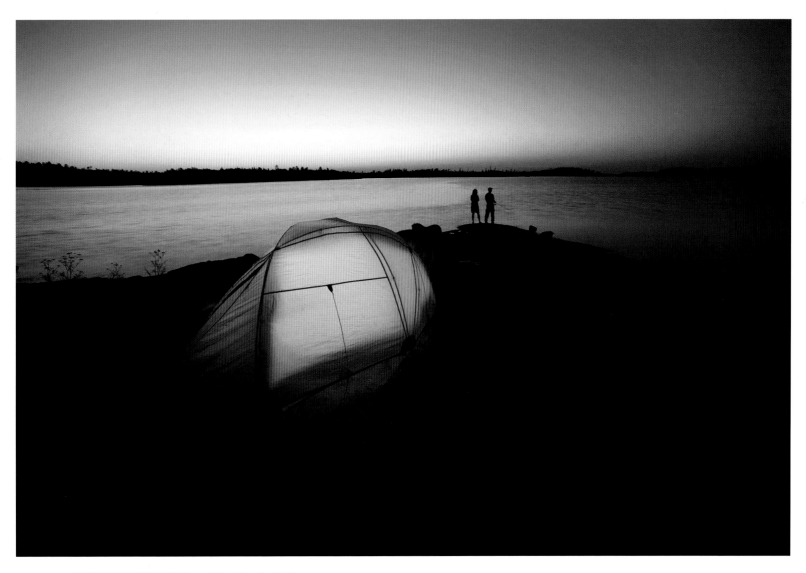

ROUTE WESTWARD. *Sunset on Lac la Croix*

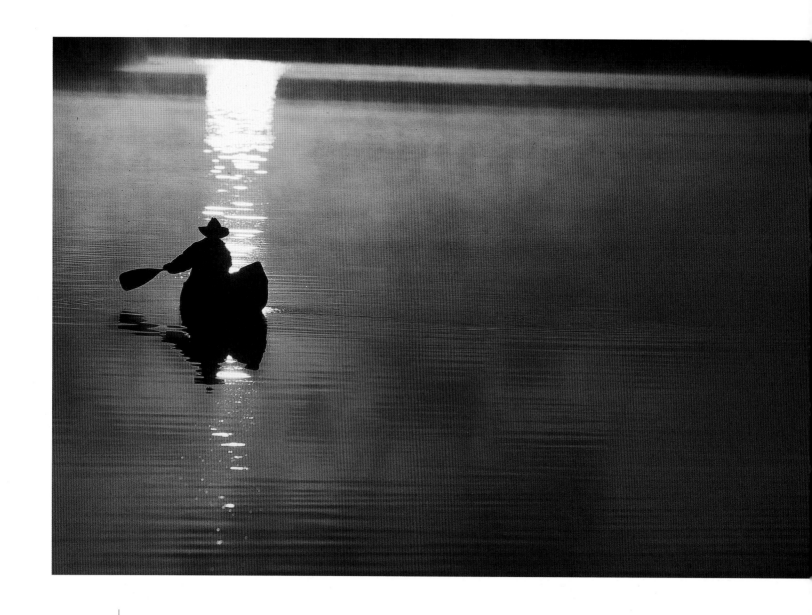

 SOLO PADDLER. *Saganaga Lake at sunrise*

# II ❧ The Dream of a Canoe

Long ago my smoldering dream of exploring the north woods flickered into bright flame when my dad announced after a trip to the Minneapolis sports show that we would buy a canoe. He had brought home a brochure that pictured a two-toned craft made of fiberglass, with an upswept bow and stern as swoopy as fins on a '59 Cadillac.

Looking back, I realize it was probably a terrible canoe—wide, slow, and heavy. Since no one was likely to turn it upside down to sleep beneath it, the exaggerated ends served no purpose except to catch crosswinds on the lake and obscure your vision when the boat was tied to the top of your car.

But back when I was eleven or twelve, I realized none of that. I thought only of possibilities—of traveling down the creek that flowed from the lake where we had our cabin, a stream too small and winding for the rowboat. Or of riding the rapids of a white-water stream. Or most of all, of packing tent and gear and disappearing down a wilderness waterway for days or even weeks, of traveling according to no one's schedule, but only as fast as the water and your effort would carry you.

In the end, my dad bought a different canoe—a serviceable aluminum boat fifteen feet long, and slow in the water. In later years I would abuse it in white water. But the first order of business back then, as I recall, was a trip into canoe country—my dad, my younger brother, and I. We didn't have great ambitions. Our gear was heavy. And with three of us, the fifteen-footer was severely taxed. We paddled several miles, made perhaps five very short portages, and set camp. There we stayed, crammed each night into a tiny army mountain tent, for the next three or four days.

It may have been a tenderfoot's trip, but it told me what I needed to know: There's a reason we call it canoe country, and it's not just the fact you see a lot of canoes in downtown Ely, our jumping-off point on the edge of the wilderness. The canoe is a keystone to the history and identity of the border lakes. The canoe is of

this land; and the land is of the canoe. Indeed, were it not for the canoe, we might not think of this place very much at all. The canoe has allowed humans to navigate this land for millennia. The canoe opened the door to the exploration not only of the Boundary Waters and Quetico, but the interior of North America clear north to the Arctic. And without the canoe, the border lakes wouldn't be the treasure they are today, for the simple reason they wouldn't be nearly so accessible and fun to explore.

Imagine the first people to reach the border country. Thousands of years ago, hunters followed vast herds of caribou along the retreating margin of glaciers and Glacial Lake Agassiz. It was a new and raw land— some of the last land anywhere without people. They traveled a rugged, nearly barren ground with tundra plants and stunted black spruce in the sheltering swales and lee sides of cliffs. But *how* did they arrive? By land? Or by water, paddling down the meltwater streams and new lakes in the bedrock and barren gravel?

With time, bristly spruce and, later, hardwoods and pine spread across the landscape. Melting ice and precipitation filled thousands of basins, and streams cut across the country like veins. Depressions filled with sphagnum and sedges. Water was everywhere, in every form, a confounding barrier to a person on foot, at least until ice formed in winter. It must have been a miserable land to walk. Ask anyone who has gotten turned around on a portage. Or any of the many hikers who have lost their way on the notorious Kekekabic Trail and wandered for days, their progress impeded by streams, lakes, black ash swamps, and peat bogs.

But to the clever human with a canoe, this water is a gift, a ticket to see the world. If the original inhabitants of canoe country didn't arrive by canoe, they soon developed the skill of building them. Throughout the Boundary Waters are sites where nomads camped 6,000 years ago. At some sites, according to one federal archaeologist, stone hammers and adzes exist among thick deposits of charcoal—too much charcoal to be accounted for by campfires or even wildfire. People seem to have been using hot coals and heavy stone tools to hollow out logs for dugout canoes.

We have no idea what these boats might have looked like, how big they were, or the cut of their bow and stern. No traces have been found. But dugouts are

common throughout the world. It's easy to imagine that early inhabitants paddled them long distances on big lakes and the long arteries that run through the region, such as the Namakan, Rainy, and Big Fork rivers.

But if you've ever tried to carry a dugout, you know how hard it would be to leave these main waterways to hunt moose or set camp on some out-of-the way stream or landlocked lake. I paddled one once with forest rangers on a tidal stream in Java. When we encountered deadfalls across the waterway, it took six of us to lift the dense, waterlogged vessel. In canoe country 6,000 years ago, it would have taken a village to portage a canoe.

Then somehow, somewhere, a birch-bark canoe appeared. Did newcomers bring this technology? Did the knowledge spread from trading partners? No one knows much about the origins of bark canoes, in part because they are too fragile to survive in the archaeological record. But their appearance must have been revolutionary. A bark canoe weighs a fraction of what a dugout does. Now, a single person could paddle this radically nimble boat to the end of a lake and, instead of dragging it or leaving it behind, flip it to his shoulders and hike to the next body of water. Rocky shores or impassible waterways no longer prevented people from traveling farther in search of new hunting grounds. People would gain better access to staples such as wild rice and furs. They could travel more quickly, in smaller groups, in response to changing conditions and the seasons.

⟡

IN CREATING A CANOE, A BUILDER constantly battles limitations imposed by his materials. The fragility of birch bark and the need for cedar sheathing and ribs to hold a shape set a minimum weight for a practical canoe. Ribs could be bent only so sharply to form the narrowing hull toward bow and stern. Early builders must have anguished over these compromises. The strongest canoe is not the lightest canoe. The fastest canoe does not turn most easily. The most stable canoe at rest is not seaworthy in the standing waves of rushing rapids or the wind-driven swells of open water. Facing these conflicting demands, the tribes of the northern birch country, from the Malecites of the Eastern Seaboard to the Ojibwe of the Quetico-Superior and the Gwich'in of the Yukon and Alaska, produced

canoes that were light, strong, and fast. Their shapes demonstrated great sophistication of design. Distinctive bow and stern profiles suggest tribal styles developed over generations or centuries.

The bark canoe had evolved to such a high achievement that European explorers and traders immediately recognized its superiority to their own carvel-planked bateaux, made with longitudinal boards. Canoes were faster and more maneuverable. A paddler, unlike a rower, faced forward and could easily see where he was going. He could carry his boat as he needed.

Early Europeans in the Boundary Waters region used the innovation just as they found it, except they built them bigger for carrying heavy fur-trade cargo. Canoes were "a rare example of an indigenous technology that completely replaced the imported technology," said Jeremy Ward, curator of the Canadian Canoe Museum. "To get into the interior, for a couple of hundred years anyway, the best way to do it was bark canoes."

Present-day *coureur de bois* Erik Simula lives at the end of a road, off the grid, near the eastern Boundary Waters. He likes "the old ways." Among other things, he builds birch-bark canoes, which he admires for their beauty and utility. Over the years he has studied their construction in "every way possible": extensive reading, trial and error, and dropping in on two masters of the trade. One was Henri Vaillancourt, the New Hampshire master that John McPhee profiled in *Survival of the Bark Canoe*. The other was Ray Boessel, Jr., the northern Minnesota canoe builder who learned the trade from the legendary Bill Hafeman. Hafeman built his first canoe because, as he once explained to me, he needed a boat for trapping and paddling nine miles on the Big Fork River to buy groceries.

Recently Simula built himself a "hunting canoe." Only thirteen feet long, with the upturned ends of ancient Ojibwe design, it is made for the solo paddler, traveling light, presumably to find game. Despite his canoe's diminutive dimensions, Simula loaded in his dog and an ungodly amount of gear until the boat settled nearly to the gunwales. Setting out in April, he paddled south from Grand Portage at the northeastern tip of Minnesota down the ice-strewn shore of Lake Superior before heading up the St. Louis River at Duluth. He retraced several historic Indian and fur-trade routes through northeastern Minnesota, finally heading east along the international

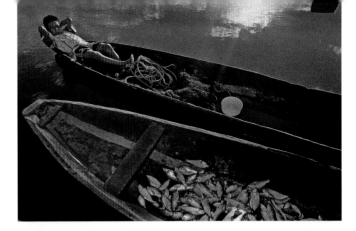

border—the famous voyageurs' highway that connects the Boundary Waters interior to Lake Superior. Simula arrived back at Grand Portage in August for the annual powwow and rendezvous held at the reconstructed North West Company fort. By that time, he had paddled 1,000 miles, toted his canoe down hundreds of portages, and dragged it over deadfalls and beaver dams. The little craft, forty-five pounds dry and ten pounds heavier when waterlogged from use, performed admirably. Along the way he had to re-gum the seams and repair sections of bark innumerable times. But that revealed the genius of the Indian inventors. They traded the weight and indestructibility of the dugout for a vessel they could carry. If a bit fragile, it could be completely rebuilt within a day with materials found in the forest.

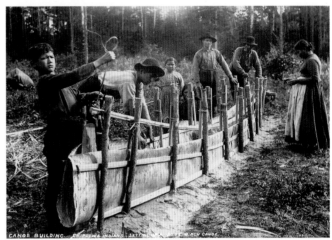

SOMETIME IN THE DAYS OF THE FUR TRADE, enterprising fix-it-uppers realized a scrap of canvas could patch a birch-bark canoe if bark itself weren't handy. Soon, native craftsmen, who were hired to build many of the canoes used in the trade, were constructing canoes with

BIRCH-BARK CANOES, *such as one under construction by Ojibwe Indians about a century ago, were superior to dugouts because of their light weight. A contemporary bark canoe (right) scribed with the image of a moose.*

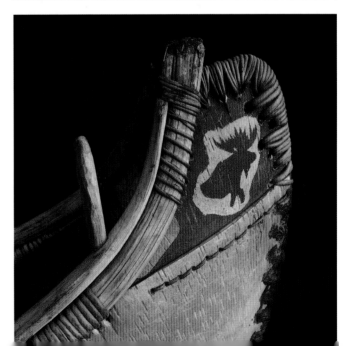

THE DREAM OF A CANOE

canvas skins in the old birch-bark fashion—right-side up, laying in the hull first and inserting sheathing and ribs afterward. Later, others began building them the European way—on a form, the hull upside down.

Never before had the canoe looked so sharp and trim, with ribs and planking of northern white cedar varnished honey gold and a smooth skin of oil-painted canvas. Their lines were as fine and graceful as those of any canoes that ever floated. Legendary are nineteenth-century models such as Chestnut's Prospector or E. M. White's Guide. This tradition of beauty with functionality is carried on by builders today on both sides of the border.

Joe Seliga, a legendary builder in Ely, constructed wood-and-canvas canoes for, among others, the Boy Scouts and YMCA camps around the Boundary Waters. He patterned his boats after the distinctive Ojibwe "long-nose" canoes. Like all fine wood and canvas boats, they had a character, a spirit. When I think of them, I think also of the painterly covers of outdoor magazines from the early to mid-1900s, with paddlers in wool shirts and fedoras. The canoes themselves were quiet, not loud, solid but not brittle. I took two trips as a Boy Scout from the Charles L. Sommers Wilderness Canoe Base near Ely. The guides, most of them young men on summer break from college, paddled wood-and-canvas canoes. The most desired were Seliga's. With an experienced guide in the stern, they cut through the water like stately cruisers. The guides pampered and prized them, though by the end of the summer they had soaked up enough water to weigh twenty or even thirty pounds more than the aluminum canoes left to the tenderfeet.

Aluminum canoes symbolized the decline in the craft of canoe building. The gorgeous lines of the wood-and-canvas version just didn't translate into metal, and the mass-produced boats lacked diversity. They seemed all of a kind, lowest common denominators—and not very good ones at that. They were a bit short, wide, very stable but slow, and abruptly broad in the bow and stern. Graced with keels that caught rocks and dragged through the water, they rang out loudly with each scuff of the foot or scrape on an unseen hazard. The soft metal stuck to every rock it touched and left a bright warning behind. I keep one at my cabin, though, because I can leave it on a pair of sawhorses outdoors all year long, through sun, rain, and snow.

WHEN I CHOOSE A CANOE, I weigh the same compromises that early canoeists did. Slow and maneuverable? Light and fast? If I paddle a rocky stream, my choice is a beamy canoe of Royalex, with a bit of rocker. It turns and leans and absorbs the abuse of rocks. I can run white water. I can even stand and fly-cast for smallmouth bass as I bob down a riffle.

But if I'm traveling canoe country, I take my eighteen-foot canoe made of another synthetic, Kevlar. It's not a perfect wilderness craft. Its sides are too low, and the bow isn't buoyant enough to take big waves, especially when loaded. But it weighs less than forty pounds, an easy carry on a portage, and when the wind is light it is the fastest thing on the water. When I first tried it, I was startled that it seemed to leap through the water with every bite of the paddle. Even now, with each stroke I feel there are no bounds to how far I can travel. This is all that I dreamed a canoe would be more than forty years ago, a bridge between land and water, a link between past and present, a means to move with the silence of a feather on the current, possessed of graceful lines honed by time and experience.

None of this, of course, comes to mind the first time you clamber into a canoe. To a beginner, a canoe is anything but liberating. It is willful, threatening to flip you out at any moment, wandering off in a direction of its own choosing. It is an impediment to travel, never going where you want, blown this way and that by the wind.

When our daughter and son-in-law first launched their canoe in the Boundary Waters, neither had paddled much. Straight away, they crashed into the grassy banks of a narrow stream. But, within an hour, they managed to guide the canoe more or less where they wanted. After a few days, they paddled confidently, even joyously, despite a headwind. Addie, weighing barely a hundred pounds, hoisted the food pack and set off down the portage. Her husband, Marc, strapped on another pack and shouldered one of the canoes. With a bit of practice, we were single-tripping the portages, wasting no time coming back for a second load. They were eager to explore, to follow the water and trails wherever they led. In no time at all, they had discovered the possibilities of a canoe and the true spirit of canoe country.

**MODERN BARK BUILDER** *Erik Simula at Grand Portage National Monument and portaging with his dog, Kitigan. The Indian tumpline, a sling fitted across the forehead (lower right), makes carrying heavy loads possible.*

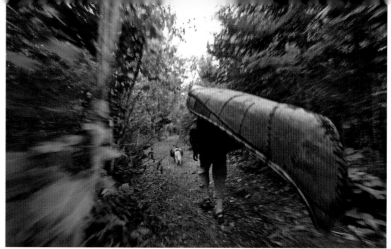

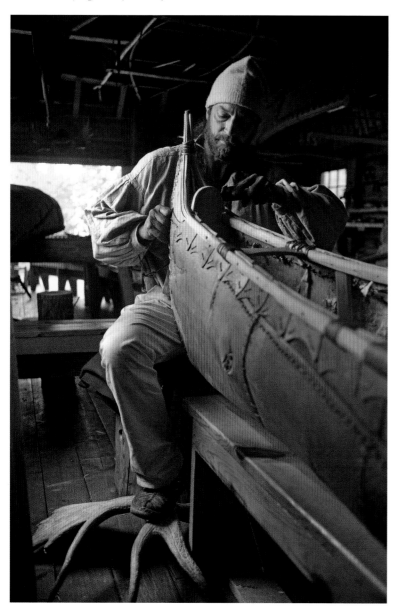

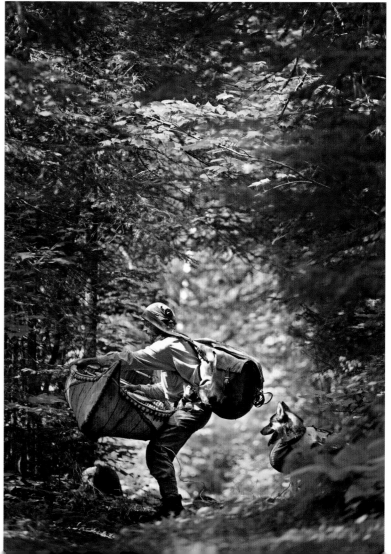

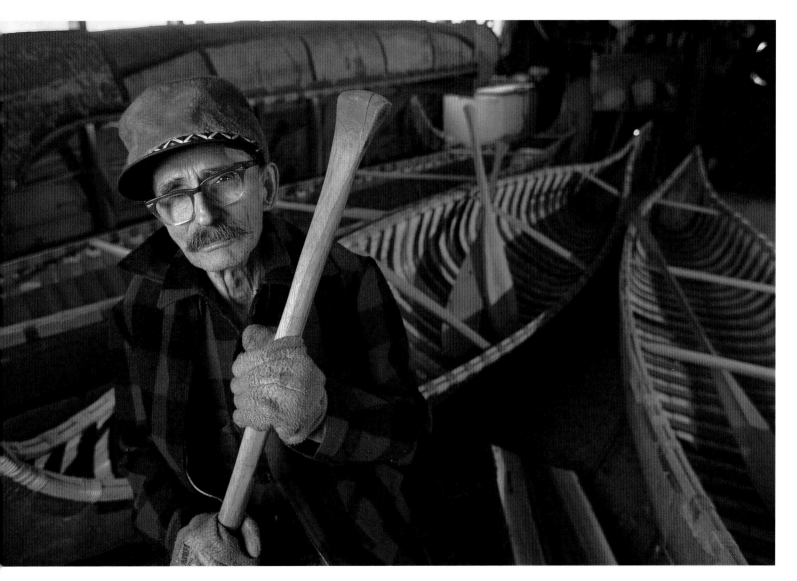

SAVING TRADITION. *The late Bill Hafeman built bark canoes in his Big Fork, Minnesota, workshop when few others possessed or practiced the skill.*

THE DREAM OF A CANOE

ALUMINUM CANOES, *on a car in Grand Marais and stacked at Gunflint Northwoods Outfitters, make up in maintenance-free durability what they lack in grace.*

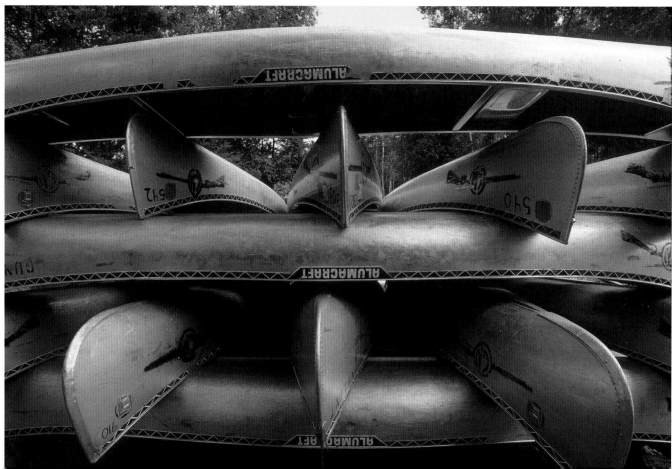

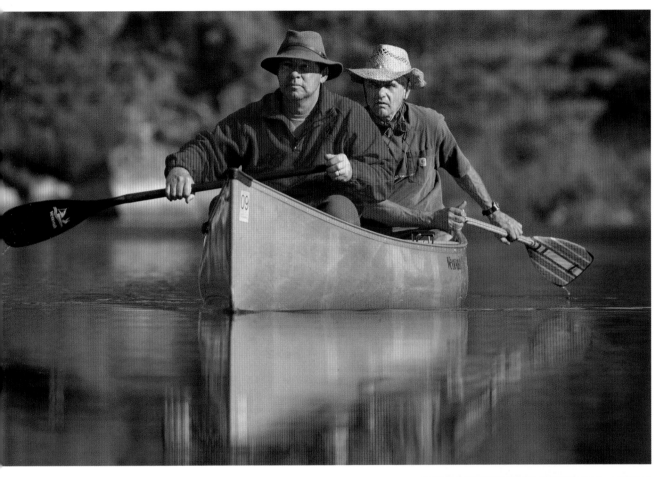

KEVLAR CANOES, like birch-bark canoes, are lightweight and make portaging easy, extending the range of paddlers along north country waterways.

WENONAH CANOE founder Mike Cichanowski displays molds for fiberglass and Kevlar canoes, which may weigh as little as 30 pounds.

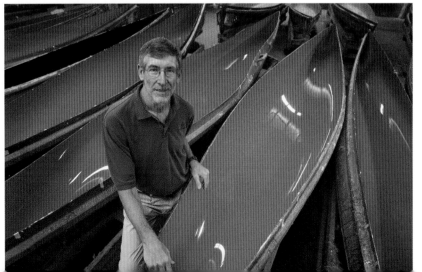

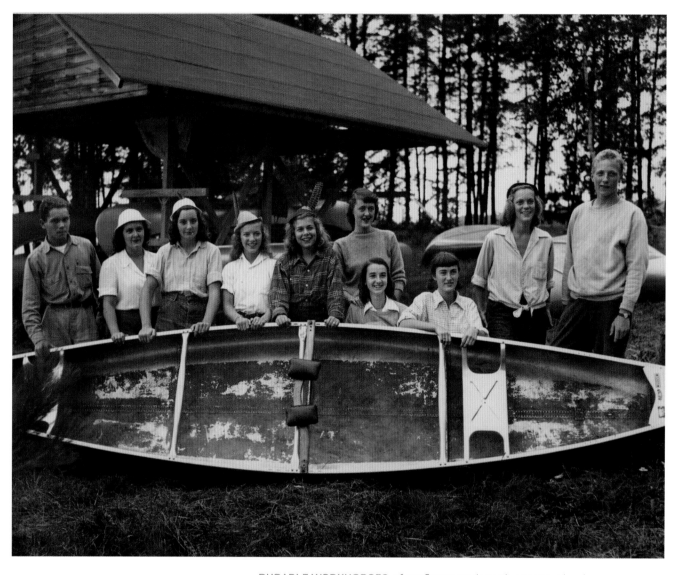

DURABLE WORKHORSES *of outfitters and youth camps, aluminum canoes carried into the wilderness countless tenderfeet, including these campers at* YMCA *Camp Widjiwagan, along the Echo Trail near Ely, 1948.*

WOOD CANOES *covered with fabric, such as this one on a portage near Lac la Croix (top) or two craft on display at the North House Folk School annual boat show, bring a high level of beauty to building.*

# the genius of a canoe

**Indian birch-bark canoes impressed Europeans** with their speed and light weight. French explorer Samuel de Champlain reported seeing a bark canoe more than twenty feet long that could be carried by a single man. Paddled by two, it could overtake a fully manned longboat.

---

**Bark canoes achieved their greatest art in the** Great Lakes and St. Lawrence region, but they are not unique to North America. Siberian Yakuts and the Ainu of Japan were known to have built birch-bark craft. Canoes were also made of other materials—spruce bark by the Abenaki, moose hide by the Malecite, and elm and hickory bark by the Iroquois.

---

**Settlement patterns among ancient Indians in** border lake country changed from clusters on major lakes and rivers to wide distribution on small lakes and streams. Undoubtedly, the birch-bark canoe played a crucial role in making these areas more accessible.

---

**The Montreal canoe, paddled by voyageurs on the** Great Lakes, measured thirty-six feet long and six feet across. It carried up to four tons. The north canoe, used inland from Grand Portage, measured twenty-five feet, with a capacity of less than two tons.

---

**Edwin Tappan Adney built his first bark canoe with** Malecite Indian Peter Joe in 1889 and later wrote *The Bark Canoes and Skin Boats of North America*, still the most authoritative source on building these boats.

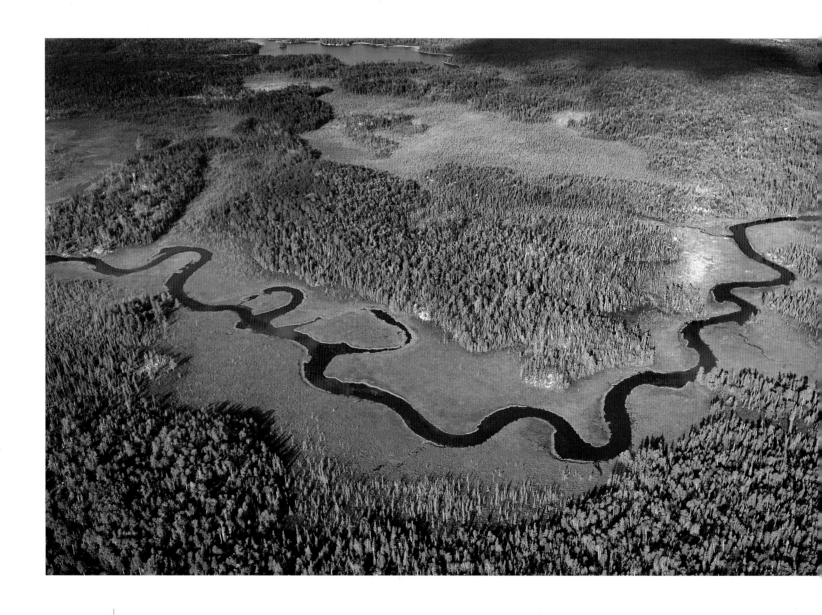

FLOWING BY GOWAN LAKE *in the distance, the upper Little Indian Sioux River scrawls across bog and forest, an important route through the western Boundary Waters to Lac la Croix on the border.*

# III ❧ A Map in the Mind

A TRIP THROUGH CANOE COUNTRY BEGINS AS A MAP—first in the hand, and then in the mind. With the crinkle and scratch of waterproofed paper, a landscape unrolls—spots of blue and squiggles, dotted lines, and concentric gray contours.

With experience we're able to translate this sheet of paper into a land of lakes, streams and rivers, portages, hills and valleys. It is exciting to see the landscape unfold and to imagine the opportunities for travel and exploration.

Some say that women and men navigate differently, that women follow landmarks and men construct maps. My wife gets impatient when I bury my nose in a map as we travel. We'll get there, she says. We're not lost yet. She is navigating by landmarks, while I'm busy trying to assemble a map in my mind. When I'm caught by surprise, when something appears, or fails to appear, as I expect, I must reconstruct my map.

I don't know the method people used to navigate this country of lakes and streams in ancient times, but they crossed it again and again, often for hundreds of miles at a crack. Two centuries ago, the Ojibwe navigated as if by GPS. George Nelson, a young apprentice in the fur trade, was dumbfounded that friends of friends from a hundred miles off could somehow walk straight to his door—"That they should come so straight to our lodges, located as we were in an immense forest of God knows how many thousand superficial miles, bothered me a good deal." He and an Indian friend once set out to visit a camp to trade for furs. Partway through the journey, Nelson's companion picked up the tracks of a bear. After following its long, wandering trail and killing it, his friend simply resumed a course and arrived directly at the lodges.

John Tanner, kidnapped as a child and raised by the Ojibwe, could wander knowledgeably through the border lakes between Lake Superior and the prairies of the Red River Valley. He knew his way around so precisely that his brother-in-law could anticipate exactly where Tanner would pass and ambush him at the spot along the Maligne River now called Tanner's Rapids.

How did the native inhabitants of this complicated landscape hold their landmarks in their minds? Did they draw maps for their own use? There's little evidence that they did. "Dene didn't use a map," an old Dene man from the north country told author David Pelly. He pointed to his head. "It's in here."

So how did they find important locations and retrace routes? As humans roamed far and wide, often in open landscapes that encouraged visualization of space, they composed their mental maps. Experience established the framework. Conversations added details. Stories gave meaning to a web of time and space. People surely needed not only to follow their own map but to convey directions to others, so perhaps a word led to a gesture, and then to a line in the dirt.

Three centuries ago, at the mouth of the Kaministiquia River (now Thunder Bay, Ontario), French army officer and explorer La Vérendrye asked Auchagah, a Cree Indian, to show him a water route west. Referencing the knowledge of other Cree and adding his own, Auchagah sketched a map. His schematic showed, like a string of pearls of wildly varying sizes, lakes and connecting streams and portages leading westward from Lake Superior deep into North America. It was a map Auchagah undoubtedly had been building in his mind for years, and no one knows if he had ever had reason to draw it before. The map was knowledge. And knowledge was the power that transformed this country from a perplexing barrier of bogs and sloughs into a convenient highway of lakes and streams.

As European groups vied for dominance over the north country, they struggled to fill in these details for themselves. Often they gave names to honor the new regime. But often, too, they saw the wisdom of the original names and kept them in translations, or even in original forms: Knife, Sturgeon, and Gunflint. Namakan (sturgeon), Ogishkemuncie (kingfisher), Kekekabic (hawk-iron), and Saganaga (possibly "islands").

*⁓*

WHENEVER WE USE A MAP, whether it is in our minds or on paper in front of us, there's constant interplay between the map and the landscape. Is this lake the one I remember? Does this island show on the map? Does reality comport with the printed image? A quick check of the compass confirms a stream bends north. A glance to

the side verifies that the portage trail skirts a bay. Having a map, whether in your head or in your hands, forces you to examine the land closely and constantly, comparing abstraction with concrete reality.

As I have followed a route through canoe country —paddling across vast lakes, through crooked channels, down narrow streams—I have wondered how I might fare were I blindfolded and dumped somewhere in the middle of the wilderness. Just me and a map and a canoe. Could I determine where I was, much less find my way out? I should have a month's worth of food, just to make sure.

When I first used a GPS to navigate, I realized that in subtle ways it breaks our ties with the landscape. Instead, we have a relationship with the heavens, in the form of satellite signals. The GPS draws your map for you. In theory you could navigate a route without looking up at the land at all—just down at the screen as the device consults with the sky. GPS encourages a kind of nearsightedness. You don't have to see where you are to know where you are. And so, as helpful and accurate as they are, I prefer not to use them.

Not everything, of course, is to be found on a map. And not everything found on some maps can be seen. Maps made by Stone Age Europeans include puzzling signs that do not seem to correspond to the actual landscape but to a spirit world that existed parallel with the trees, lakes, and rivers. Painted pictographs—figures of animals, men, canoes, and abstract shapes on slabs of granite overhanging the water—also seem to refer to such a world. Some suggest travel, direction, or relationships of time and space. Archaeologist Thor Conway, who spent time with Ojibwe medicine men who guardedly began to confide in him, reports that pictographs appeared only at cliffs associated with resident spirits. These places of power, portals to a parallel world, must have existed in the mental maps of native people.

Author Louise Erdrich says the rock paintings reflect a "spiritual geography." A leader of the Lac la Croix Ojibwe told me something tellingly similar—that the pictographs were a message, guidance from the long dead to the living. "We believe those painted rocks were painted for a reason—to send a message to us, and to the generations to come."

If so, they are a kind of marker of the unseen, a topology of intersecting worlds—one of water and rock and wood, the other of story and dreams and mystery.

They are maps to help the living navigate the world of the spirits.

<center>◇</center>

THE MAPS I BUY TODAY OFFER MORE DETAILS—larger scale, contour lines, canoe campsites—than any I used as a boy. Sitting at my computer, I can pull up aerial photos and Google satellite images of any lake in the Boundary Waters. Yet, as preservationist Sigurd Olson wrote, "How little we know when we see only rocks and trees and waters, mountains and meadows and prairies." It is sometimes better not to know, but to discover as you go.

Recently I headed to canoe country with a couple of beginners. We had intended simply to take a few short portages into the Boundary Waters, set up a base camp, canoe and fish for a few days, and retrace our route home.

But the kids took to canoe travel with un-expected aplomb. Rather than stay in our camp, they wanted to pull up stakes, paddle down a stream, and then go to a different lake. The next day, they voted to strike camp again. Could we, they asked, travel a loop rather than retrace our steps?

We could, I said, but for one problem: We had traveled to the edge of our detailed map. The only chart we had to guide us was a back-up that showed the entire sweep of canoe country on a single sheet—thousands of square miles with hardly any detail at all.

But they were game, and so was I. So off we went, guided only by our world atlas–scale chart. There was more white water than I expected. We missed a long portage so we had to paddle upstream and use a rope to "line" our canoes up the rapids.

By late afternoon we had set up camp at a spectacular site along a river, a campsite not shown on our deficient map, which indeed showed no sites at all. We bathed below a rapids and watched four otters frolic in the swirling water.

I was gladdened by my companions' spirit of adventure and our good fortune in what we had found here—a comfortable, secluded camp on a beautiful river. For a short time we had wandered off our chart and onto the tracings of a different one—one of things unplanned, unanticipated, whose features are not easily seen. Indeed, these are the things that cannot be shown on any map. ◇

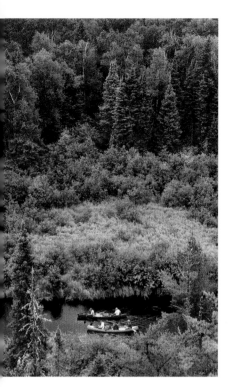

NARROW CREEKS, *such as the Nina Moose River (left), and sprawling island-studded waterways, such as Crooked Lake's Saturday Bay, have filled the maps, mental and actual, of generations of canoe travelers.*

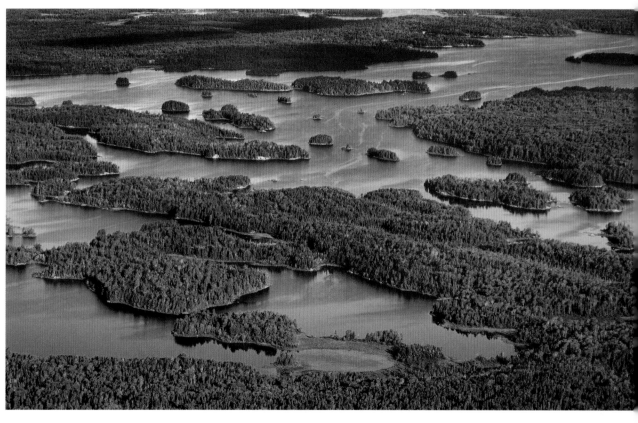

THROUGH THE AGES *and undoubtedly in several languages, canoe country travelers have asked the question, "Where are we?"* ⟶

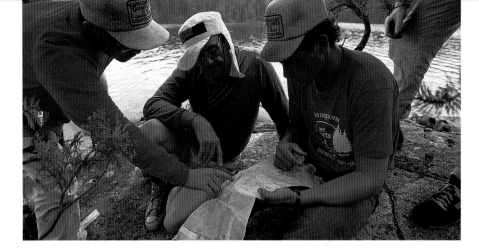

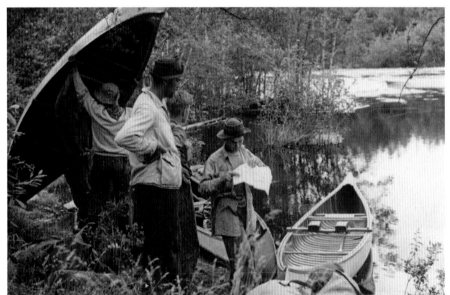

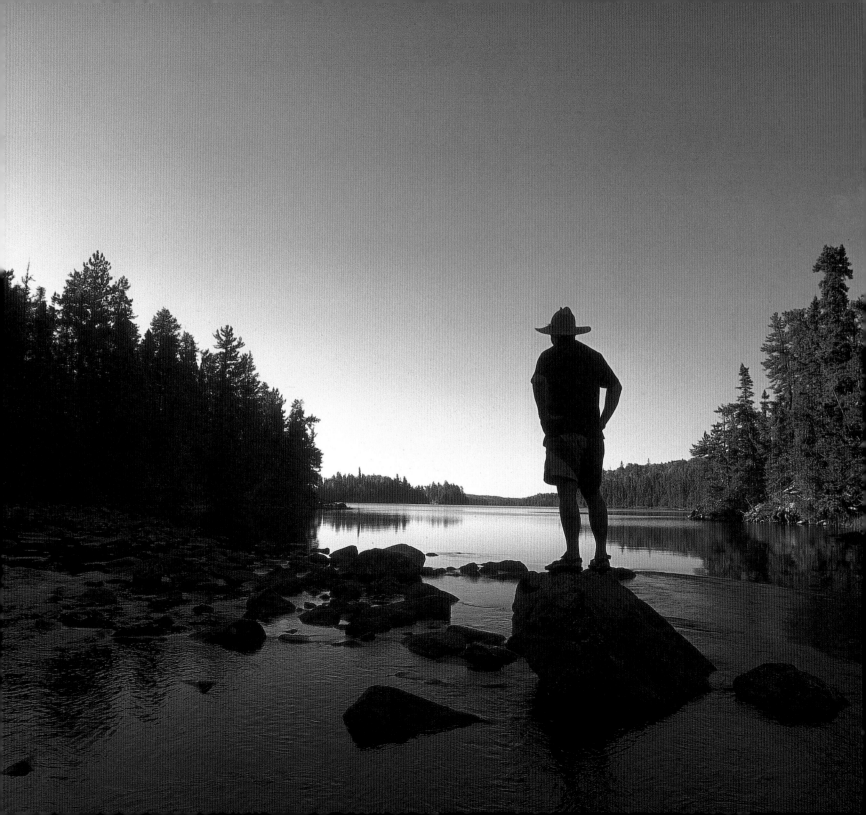

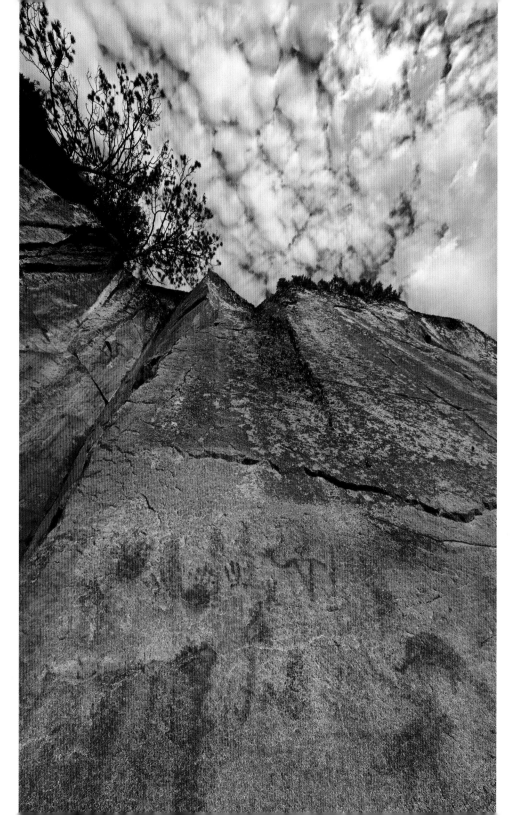

SPIRITUAL MAPS. *Pictographs of iron oxide, such as these at Lac la Croix, provided the Ojibwe a landmark in a world of spirits and timeless narratives.*

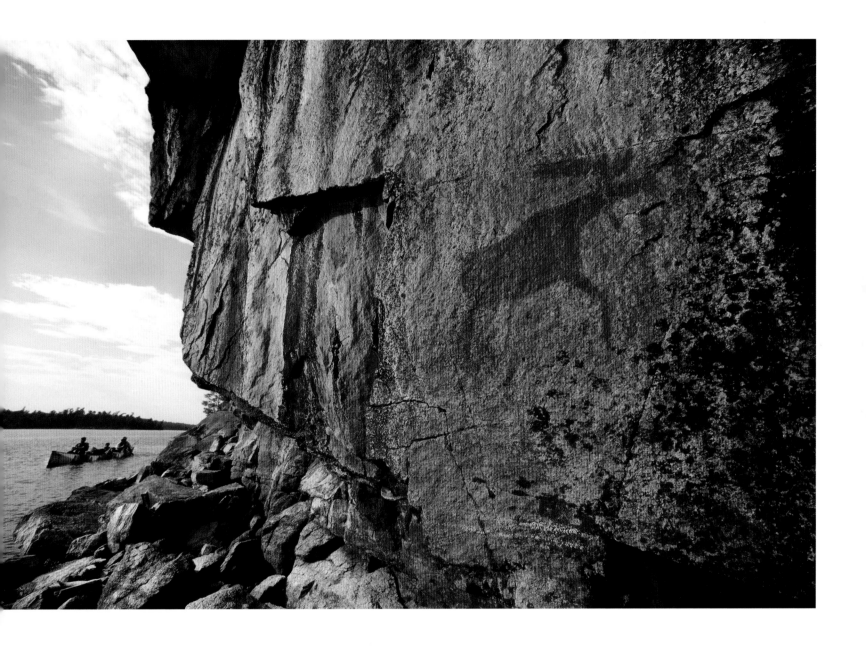

SOULS' PATHWAY. *The Milky Way and Perseids meteor trails over Nina Moose Lake* →

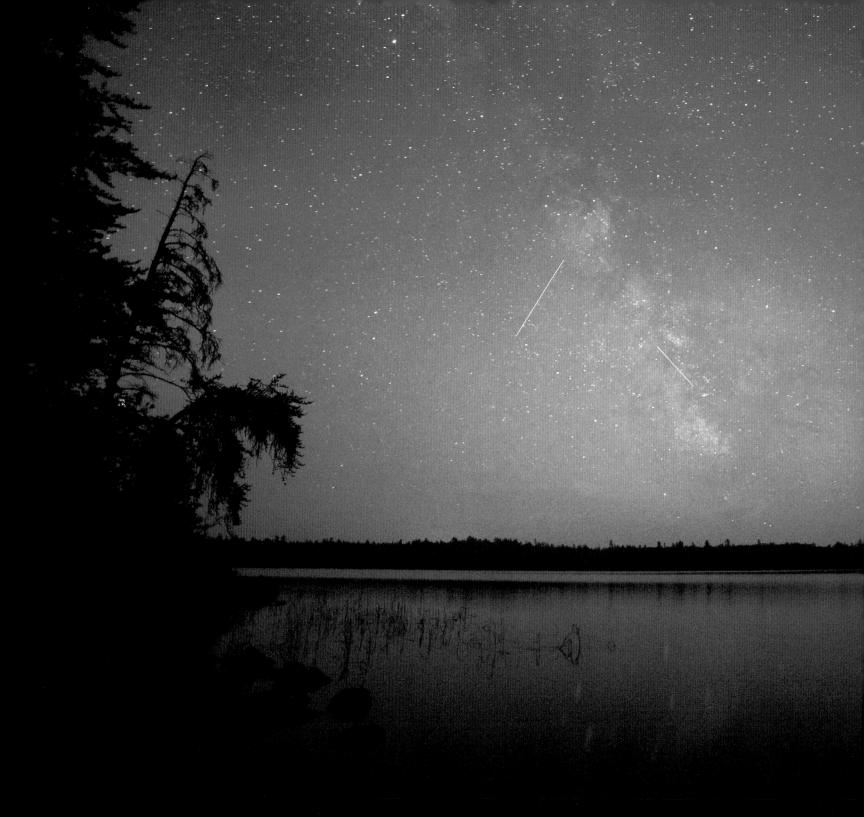

## mapping canoe country

**No one is sure which European explorer first set foot** in the border country. It may have been Pierre-Esprit Radisson and Médard Chouart des Groseilliers, who passed through the western Lake Superior region in the late 1650s. In 1688 Jacques de Noyon ascended the Kaministiquia and wintered at Rainy Lake. The Cree and Assiniboine lived in the region then, soon to be pushed out by the Ojibwe.

---

**David Thompson, a poor lad from London, became** the preeminent cartographer of early Canada, producing the most complete maps of the border country during his tenure with the North West Company beginning in 1797. His map of the northwest from Lake Superior to the Pacific hung in the great hall at Kaministiquia, later named Fort William.

---

**The best consumer maps for canoe country today** are made by W. A. Fisher Maps and Publications, McKenzie Maps, and Voyageur Maps. Each is printed on waterproof paper and shows lakes and streams, campsites, portages, and significant topography. Voyageur's maps offer more fishing and historical information. McKenzie maps have a larger scale. Some users think Fisher maps are the easiest to read.

---

**Voyageurs made "lob pines" to mark portages, camps,** and other sites. A man with an ax climbed a prominent pine and "lobbed" (that is, lopped) off the middle branches, leaving a pompom on top. Voyageurs would name the pine in honor of a fur company manager or guest in the canoe, who was then obligated to open a keg for a round of shrub, wine, or rum.

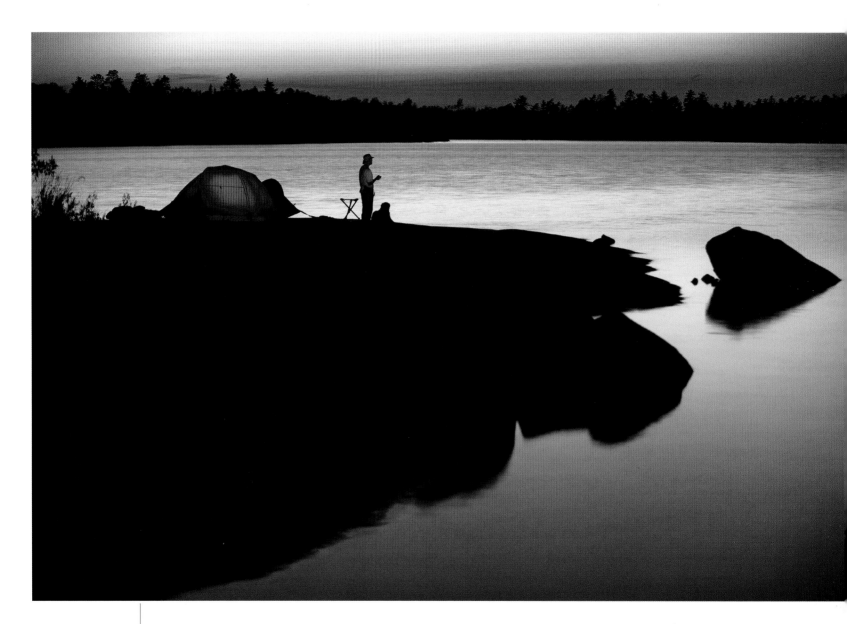

 ROCKY OUTPOST. *Twilight on Lac la Croix*

# IV ❧ BONES OF THE EARTH

YOU HEAR THE POETRY OF GEOLOGY IN THEIR NAMES: Gunflint Lake, Red Rock Lake. Iron, Copper. Boulder, Cliff. Magnetic Lake, Gneiss Lake. Granite and Jasper (actually two, one on either side of the border).

An early map labeled this area, for want of detail, Land of Rock and Water. Indeed, it is hard to picture one without the other. The reflection of a cliff in a mirror-calm lake. A stream plunging over a jumble of boulders. A sloping ledge pointing toward deep water. Bedrock gliding slowly beneath the canoe. Rock is never more than inches away.

Bedrock is the earth laid bare to the bones. It speaks to our essential nature. It is constant and enduring. *Rock of ages. The earth abideth forever.* Beneath the surface, rock looks as young as the day it was born.

The rock of canoe country is, literally, the foundation of the continent. Most of the greenstones, granites, schists—various igneous and metamorphosed rock—formed between one and nearly three billion years ago. And there they sat while the earth's geologic fireworks shifted to other areas—as India jammed into Asia, shoving up the Himalayas; as the Pacific plate crashed into the West Coast of this hemisphere, creating the continent's best ski resorts. Meanwhile the core of the North American continent, the Laurentian or Canadian Shield, canoe country, sat in dull constancy, until Ice Age glaciers, Johnny-come-latelies in the geologic scheme, bulldozed earth, cracked off chunks of bedrock, and piled boulders in heaped moraines.

Rock determines the ruggedness of canoe country. There's little soil in the region to smooth things over, to hide the underlying shape of the strata. Think of a portage trail that scales a pile of boulders or surmounts an outcrop. Or the cliffs rimming the lakes. The land is just as abrupt below water, a fact made clear when I first brought a fish-finder to canoe country. Susan and I dropped jigs a rod length from a cliff. The water went down twenty feet, thirty feet, fifty feet! At various depths schools of fish hunkered next to the wall of stone.

Rock, austere and beautiful, is central to the concept of the *sublime,* whether seen in the towering Alps that enthralled European writers or the more modest expressions of the Canadian Shield. John Dennis in 1693 wrote of the "delight" of nature "mingled with Horrours, and sometimes almost with despair." Bare rock, whether a towering mountain or a sheer cliff, has the power to inspire awe, even terror, as if it were the manifestation of a terrible god.

This idea of the sublime as a more profound beauty, or even the antithesis of beauty, found common expression among the Romantics. Why? In wild, austere places, writes historian William Cronon, we find "more chance than elsewhere to glimpse the face of God." Whence comes this feeling of awe? In the realization that our lives are fleeting in comparison to enduring bedrock? That rock, and by extension nature, will not yield? That the forces of earth dwarf the works of our own kind?

But not everyone finds rock awe-inspiring—at least not in the same way. How we feel about rock says something about our attitudes toward nature. And that depends in part on how close we are to the land in the first place.

An appreciation of the sublime requires some distance—both from the scene that so affects us and from nature itself. The Europeans who first came to canoe country weren't Romantic philosophers or fashionable poseurs. They were practical men preoccupied with practical concerns—finding their way, trading furs, staying alive—and they were likely to describe the rocky ground of canoe country or the northern shore of Lake Superior as "forsaken" or a "barren waste of rocks." In contrast, they sang the praises of places such as the Folle Avoine, the "wild oats" or wild rice district of northern Wisconsin. Less rock, more bounty.

Yet barren rock did attract the attention of practical men—but for a different reason. That reason was gold.

They found it—a bit along the Vermilion River, but only enough to lead to an abortive gold rush in 1865. Nearly thirty years later, George Davis pecked away at a six-foot-wide vein of quartz on Little American Island on Rainy Lake and—Eureka!—he discovered gold. Rainy Lake City bloomed to a community of 500. But in three years it dwindled from gold town to ghost town.

And so it went. Tantalizing traces. Just enough gold to start a few mines north of the Quetico around

Atikokan. From the Gunflint Trail, you can hike a couple of miles along the Kekekabic Trail to the gaping opening of the Paulson Mine, an iron-ore test pit dug more than a century ago. Even now, a company is planning to mine just south of the Boundary Waters for copper and precipitates of nickel, cobalt, palladium, platinum, and—yes—gold. Undoubtedly riches lie beneath the Boundary Waters and the Quetico, but they have never been found in deposits large enough or rich enough to warrant mining.

But if there were really riches in the rock, they came in the form of iron ore—a few deposits in Canada, but vast reserves in northern Minnesota. The Vermilion Iron Range opened just south of the Boundary Waters in 1884. Soon mining extended northeast all the way to Ely.

Mining almost anywhere is a hard-bitten life, filled with boom times and hard times, mistrust and frustration and anger. By the time the Boundary Waters was designated a wilderness in 1964, the Pioneer Mine, the last iron mine on the Vermilion Range, had closed for good. A history of hard rock mining, strikes, bitter relations with mining companies, and high wages didn't produce a breed of man keen to rent canoes and sell minnows to people from Minneapolis and Chicago. And in 1978, many of these

old miners and their children howled as environmentalists—and, ultimately, the U.S. Congress—backed the bill to banish logging, mining, prospecting, and most motorboat use from the northern wilderness.

And so it remains. Go to Ely and you'll get a whiff of it—a rift dividing the sons and daughters of miners and loggers from the newcomers who harbor dreams of wilderness. Is this the old tension between the Romantics and the practical men—or the romantic and practical in each of us?

THE OJIBWE HAVE YET ANOTHER ATTITUDE toward rock. It is not the hard-bitten appraisal of miners, though Indians certainly quarried rock to make tools, pecking away at the glassy Knife Lake siltstone on the banks of Mookomaan Zaaga'igan, the "lake where rock to make knives is found." (Indians even extracted and annealed copper when they could find a nearly pure vein of it.) Nor is it the Romantics' lofty and distant relationship with Nature. The Ojibwe are too closely tethered to the land for those kinds of intellectual hallucinations, though Romantics

then and New Agers today would like to believe they are all very simpatico.

Ojibwe had their own connections to rock. We hear them in the stories still told in homes, camps, and ceremonial roundhouses. We see the evidence in the figures on the cliff faces—the iron-red paintings of moose, caribou, canoes, men, and mysterious discs. The Boundary Waters and Quetico have a concentration of rock paintings unlike anywhere else between Lake Superior and Manitoba. Find them at many sites along the Basswood River, on Quetico Lake, Beaverhouse Lake, Darkey, Hegman, and Saganaga.

Yet there are many more cliffs where they *could* be and aren't. Why here and not there? Archaeologist Thor Conway suggests they appeared on places perceived to be conduits of power. This is a function of rock: a conductor of high-voltage spiritual energy. Some spirits, in particular, attach to these places, like iron filings to a magnet, among them the *mizauwabeekum* that dwell in outcrops where gold, copper, and pyrite are visible. And most notably the *maemaegawaehnssiwuk,* the small people who live in lakeside cliffs and sometimes overturn canoes, trading their powerful rock medicine for the tobacco travelers leave behind.

I am not immune to these mysteries. I don't pretend to accept the spiritual world of the Ojibwe, and I'm too skeptical to be much of a Romantic. Nonetheless, I am taken in by the spell cast by these craggy places. One evening recently, I smoked a cigar—my own tobacco ceremony—on a sloping granite outcrop beside a swift river. The trees were silhouettes in an indigo sky. A white pine across the river appeared to have been struck by lightning, its crown growing crazy in the shape of a snowflake. The rock I sat on, cool to the touch, unyielding, was so light in color as to appear buoyant. As smoke curled upward, I listened to the rush of rapids and watched the foam from the white water curl, like the smoke, downstream into the gloaming. What could be more elemental than the sound of water colliding with Precambrian rock? I wondered if it was the *maemaegawaehnssiwuk* that give voice to the rapids.

This is what it means for a landscape to be timeless: to reach halfway back to the earth's creation in a single scene, a single instant, while the call of a white-throated sparrow fades into eternity. If anything, "timelessness" makes us more acutely aware of time, the vast span of history and the people who have come before. And of our brief time in comparison. Perhaps that is the basis of the sublime. And that is why rock has the power to impress. ⌇

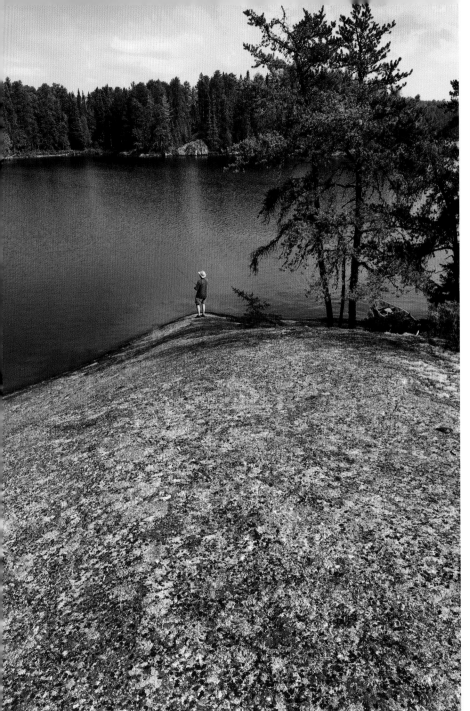

ROCK AND WATER. *In canoe country, the interplay of bedrock and water is constant. A granite dome (left) erupts from Kahshahpiwi Lake in Quetico. Water flows from Duncan Lake into Rose Lake alongside Stairway Portage on the U.S. side of the border.*

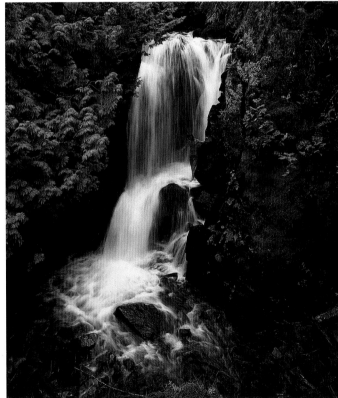

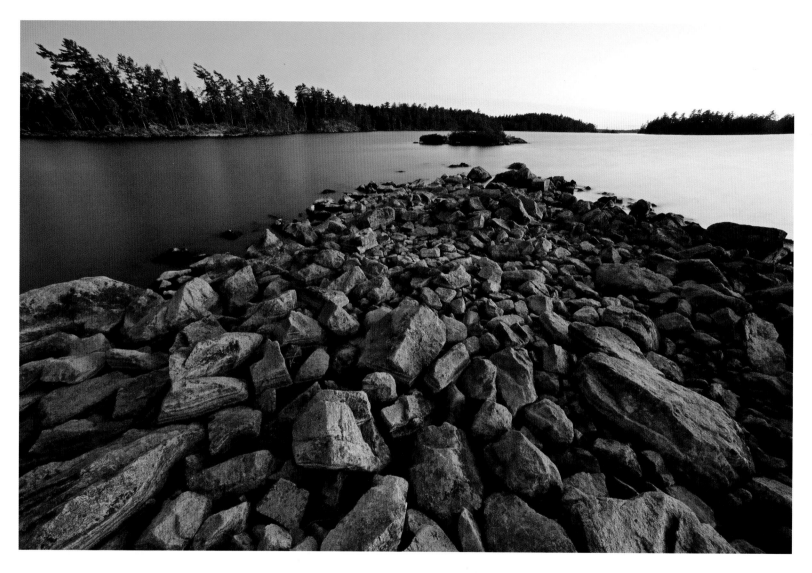

**BOULDERS BETWEEN NATIONS.** *Glacial ice deposited broken layers of gabbro and gneiss between Canadian (to the right) and U.S. islands (left) on Saganaga Lake.*

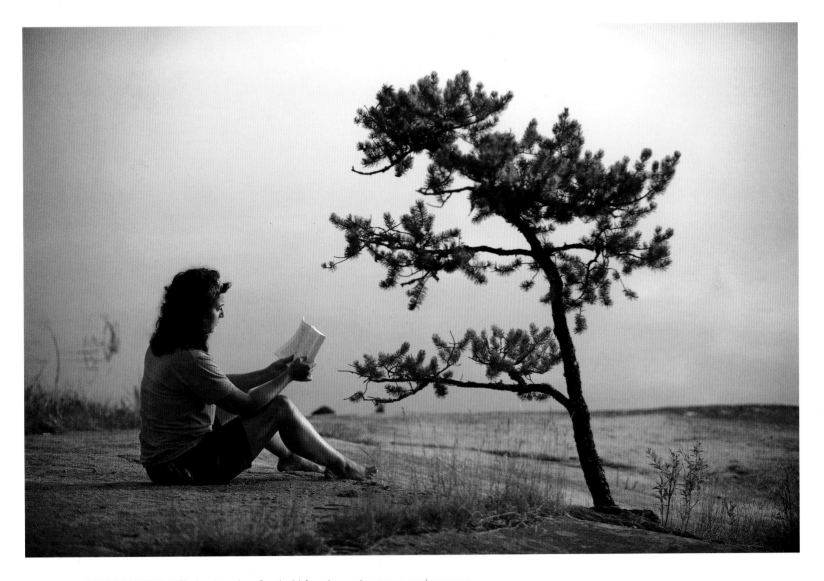

**READING ROCK.** *Offering barely a foothold for pioneering trees and grasses, sloping outcrops, such as this one on Nina Moose Lake, are an age-old hangout.*

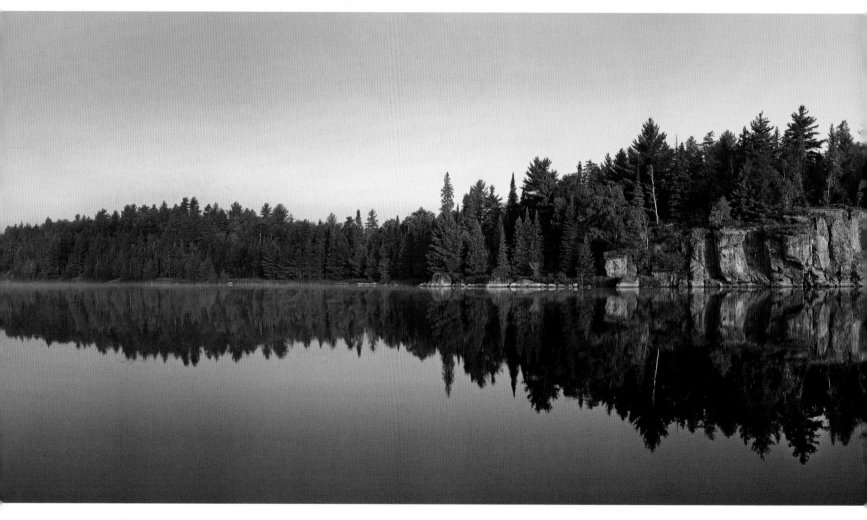

THE CANADIAN SHIELD *shows its face, north shore of Grey Lake, Quetico.*

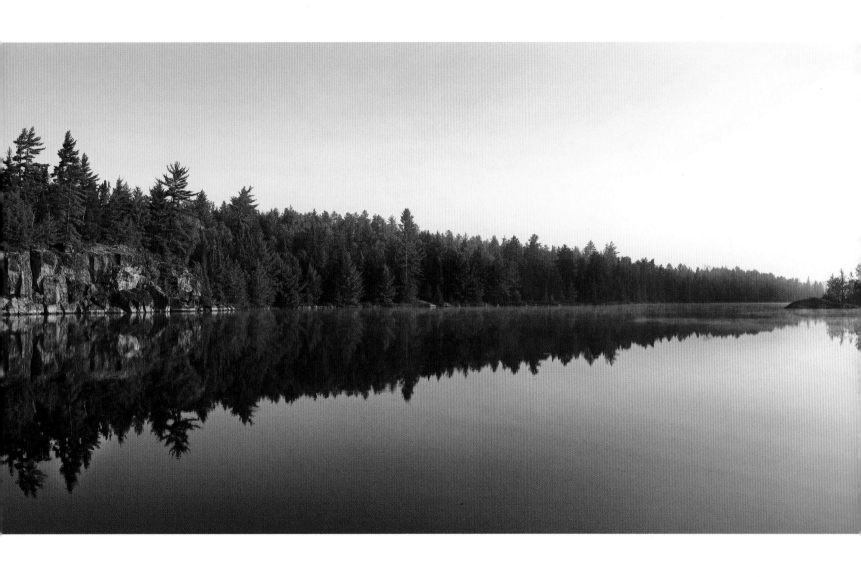

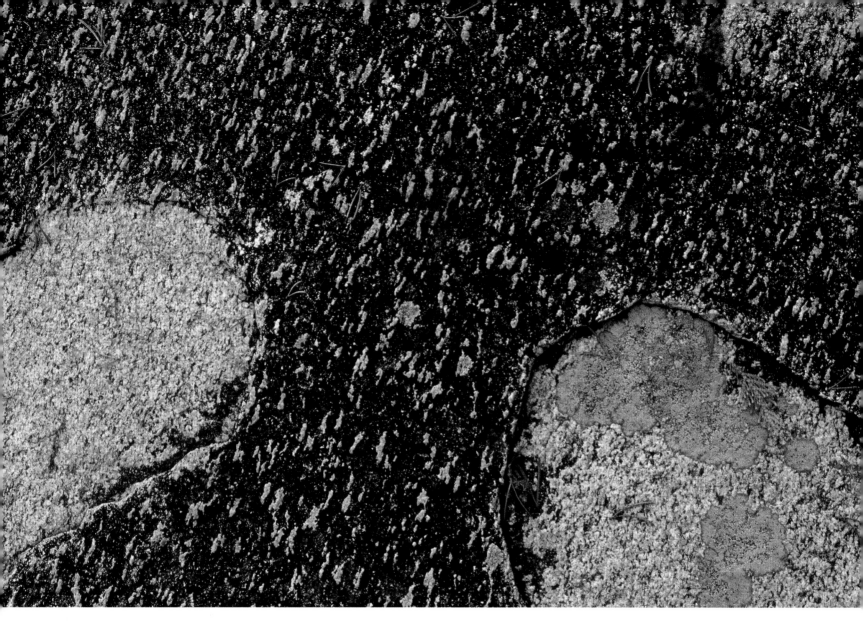

**LIGHT AND DARK.** *Black diorite with plagioclase and granite, Granite River, on the international border*

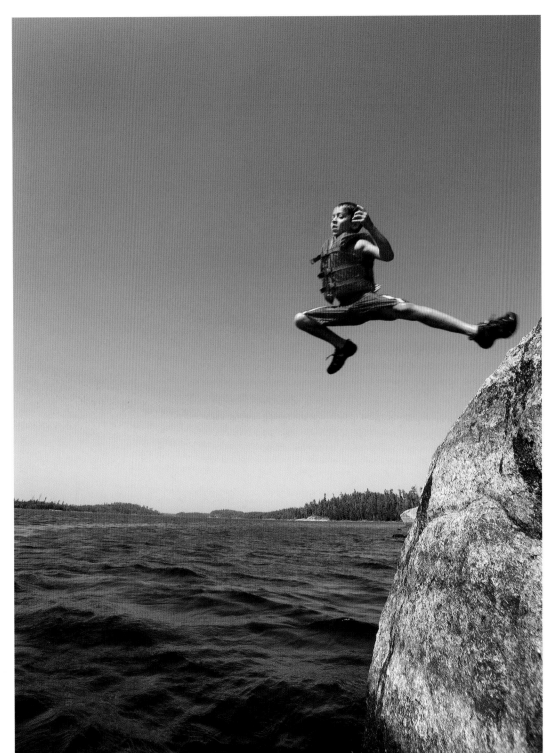

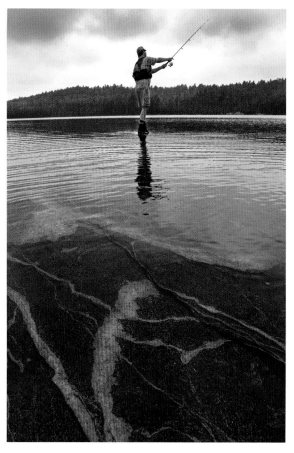

REVEL ROCK. *Swirling gneiss and quartz bedrock, Shade Lake, Quetico*

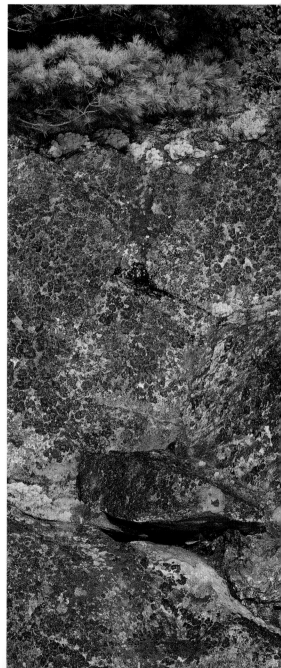

ROCKY BREAKDOWN. *The face of a granite outcrop repels most colonizers but for saxicolous lichens, a composite organism, part fungus, part algae. Lichen traps organic debris and itself breaks down, forming a thin layer of soil for encroaching plants.*

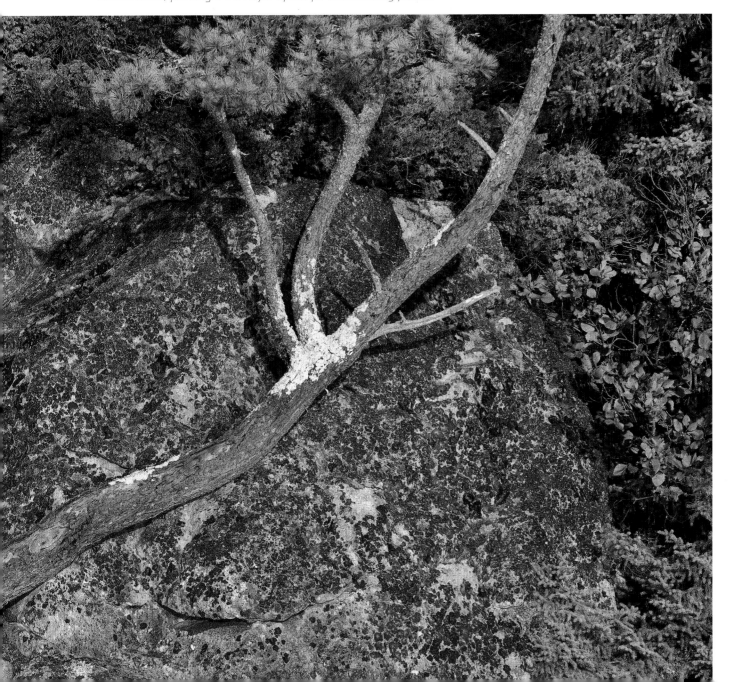

47

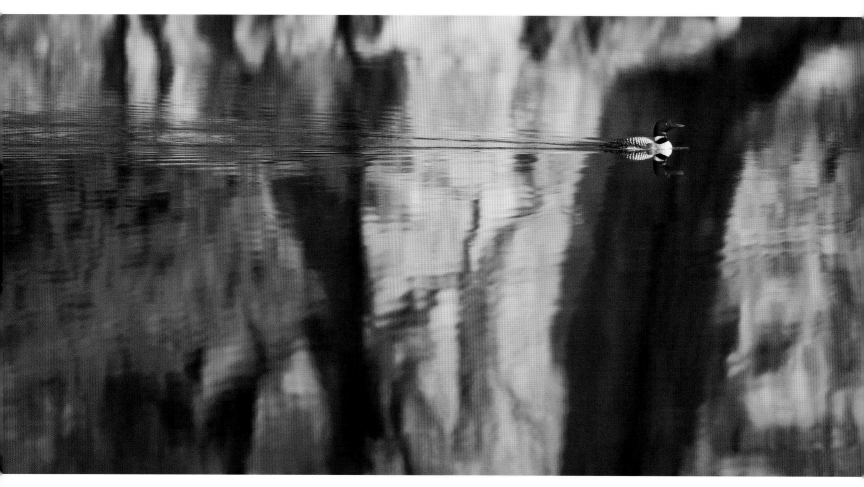

A COMMON LOON *glides through the reflection of a towering rock face.*

HONEYMOON BLUFF *rises 200 feet above Hungry Jack Lake, providing a sweeping vista, with Canadian hills in the distance.*

# rock steady

**The bedrock you stand on in canoe country is more** than half the age of the earth itself. Canoe country lies on the southwestern portion of the Canadian Precambrian Shield, the core of North America and some of the most ancient rocks on earth. Among the oldest are volcanic rocks metamorphosed by the heat and pressure of granitic intrusions 2.7 billion years ago. Generally, bare rock outcrops and cliffs become more common from west to east.

---

**Ice Age glaciers cleared the Quetico-Superior of** whatever soil and forest might have existed earlier. Glaciers retreated toward the northeast. The Boundary Waters and then the Quetico became ice free about 11,000 years ago. Deep grooves known as *striations* show where rocks bound in glacial ice scored outcrops. Many surfaces display two sets of striations in different directions, indicating two glacial movements. As the ice retreated, Glacial Lake Agassiz flooded low-lying areas.

---

**Minnesota's deepest natural lake, except Superior,** is Lake Saganaga, located in the eastern Boundary Waters.

---

**Abundant rock and copious lakes and bogs were not** universally admired, especially by those who measured the worth of land by its arability. One surveyor called the entire region "the most forsaken country it has ever been my misfortune to encounter. There is apparently nothing . . . that would induce a sane person to enter within the unsacred domain of moose, wolves, bear, snow, rain, mosquitoes, flies, rocks, swamp, brush, and rapids . . . I have been stung by mosquitoes in this township while standing in snow knee deep."

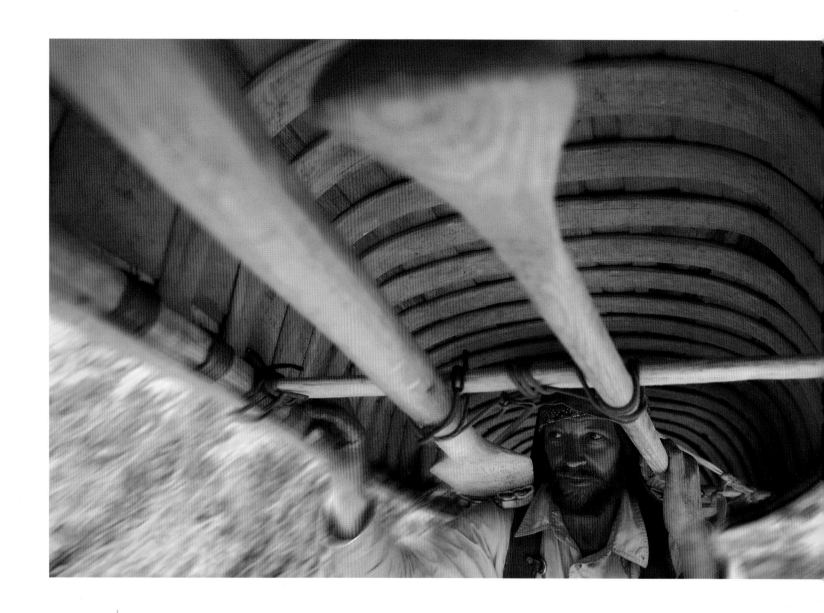

PORTAGE PARADOX. *To voyageurs and modern paddlers alike, the portage represents drudgery and mobility.*

# V ⌒ THE PORTAGE

IF ONLY THE LAKES AND RIVERS OF CANOE COUNTRY stretched on forever. But they don't. So after your canoe carries you, you must carry your canoe. If you were a French Canadian voyageur, you would call this workout a *por-TAZH*.

Around here, most of us say *POR-tij*.

Portages are strenuous. They are muddy and buggy. You are never more likely to dump a canoe, step in water over your boots, fall on your behind, break a fishing rod, or twist an ankle than on a portage. Yet, portaging offers advantages. With preparation and practice—youth and fitness don't hurt either—portages may even offer the opportunity for a bit of graceful efficiency and the satisfaction of a job well done.

When I paddled canoe country as a Boy Scout, I learned to step out of the canoe before we reached shore so the hull never touched rock. I bend this rule a bit, and the scuffed and patched bow of my Kevlar canoe proves it. Since portaging demands sloshing around, even in the icy waters of May, I am never satisfied with my footwear. Over the years, I have worn hiking boots, rubber boots, sandals, water shoes, and now boots with rubber bottoms and neoprene uppers.

The second rule I learned: Portage in a single trip to avoid wasted steps. Play this out to see how extra trips add up. Going back for a second load actually *triples* your mileage over a trail. This is no problem if the portage is a jaunt over a ledge separating lakes or around a short pitch of rapids. But if the carry approaches a mile, the extra steps add up.

If you've packed too much to manage in a single trip—several fishing rods, folding lawn chair, frozen steaks, and an environmentally correct *box* of wine (no bottles and cans allowed in canoe country)—try this old-time trick. Send the first paddler down the entire length of the portage with a full load. The second paddler carries a pack to the midpoint of the trail. The first paddler returns halfway to get the jettisoned load, while the second paddler goes back for the canoe. In all, each canoeist walks only two lengths of the portage trail.

On almost any trip, the first portages are awkward. We find we've brought too much. We've packed gear poorly. We leave loose odds and ends for a second trip. The canoe won't fit over the top of a certain pack, so we trade loads. After a few portages, the problems begin to resolve themselves. Paddlers hop out in shallow water. One shoulders the larger pack and life vests or other loose items. The second hoists the smaller pack, bungees the paddles into the boat—perhaps one in the bow and two in the stern for balance—and flips the boat on the shoulders. Then both paddlers head down the portage trail.

The scenery on a portage isn't much—not nearly as good as the view from a canoe in an upright position, with a sapphire lake and spectacular rock outcrops all around. Dense forest doesn't offer broad vistas. Even if it did, you're in no position to appreciate them. Instead, you hike in a Kevlar shadow. Lift the bow a bit to watch your partner's muddy boots plodding on the trail. Mainly you look down—dodging a root, stepping over a sharp outcrop, walking lightly around a water hole. You may be able to admire the Canada mayflower and bunchberry. But sweat trickles down your neck, and mosquitoes, descendants of the bugs that sucked the blood of voyageurs, bite your face, apparently aware that you can't slap them because your hands are clutching the canoe's gunwales.

There's a reason canoe country portages are so deeply rutted, with roots and rocks standing out in such prominent relief. These paths are older than we imagine. Thousands of years ago, the first inhabitants followed animal trails that led where they wanted to go. They took the easiest routes between lakes, aiming for the shortest distance while avoiding steep climbs and swamps. We hike many of these same trails today.

Fur-trade voyageurs were masters of the portage. Two men carried the twenty-five-foot *canot du nord*, while the rest shouldered a couple of packs at ninety pounds apiece. A canoe brigade made several trips and carried well over a ton of cargo. But only if they had to. Hauling such loads, they would do almost anything to avoid a portage. They'd line or pole their canoes, loaded or unloaded, upstream or down. They might carry some goods if it meant they could sneak through a rapids partially loaded. And often they just said the hell with it and ran a rapids. Sometimes they guessed wrong—canoes smashed against the rocks, trade goods washed down rapids, and voyageurs

camped for eternity in shoreline graves marked by wooden crosses.

Canoe country essayist Sigurd Olson reveled in following the portages of these travelers, "gathering from the earth itself the feeling and challenges of those who trod them long ago." Me, I'm not so keen. If I wanted to backpack, I'd be on the Superior Hiking Trail. Like the voyageurs, I would rather paddle. But portaging suits my purpose. Portages are both gateways and barriers. They place a hurdle in the path of someone who doesn't want to make the effort. By portaging, I can get away, go deeper into the great beyond, where fewer people go. To find these places is the reason I come to the wilderness. With this goal in mind, I find one of the purest joys of being in this country is the simple act of traveling. And nothing makes the miles glide under the hull and fly beneath your feet like the satisfying efficiency of good teamwork on a portage.

Just how impressive teamwork can be I discovered on a recent trip to the Quetico. As my wife and I lunched near the start of a portage, an afternoon storm passed overhead. We huddled beneath a tarp as rain beat down like gunshots. In the distance, the gray outline of a canoe appeared, so despite the rain, we decided to pack and begin our portage before the other canoe reached the landing and we got in each other's way.

But as Susan and I put away the tarp and food, the canoe closed with breathtaking speed. It was a lean, streamlined Kevlar boat. Two occupants, young women whose hair hung in strands plastered to their faces, wielded carbon-fiber paddles with a racing technique: *stroke, stroke, stroke, switch sides. Stroke, stroke, stroke, switch . . .* They smiled, called out a greeting, and said they were a trail crew for the park. Before we could cover the short distance between our lunch spot and the beginning of the portage, they sped past on their way to the landing.

They sprinted upstream through a swift riffle and hit the portage. One woman slipped into her pack, lifted the canoe, waded through the mud hole at the landing, and scaled the muddy slope as if there were stairs. The second woman shouldered her pack, picked up a chainsaw with one hand and a gas can with the other, and disappeared after her friend. I saw not a wasted movement. By the time Susan and I crossed the portage and slid our canoe into the next lake, the two women and their canoe were but a hazy speck in the gray distance. We could only marvel at their combination of youth, fitness, skill, and spirit. ᶜ

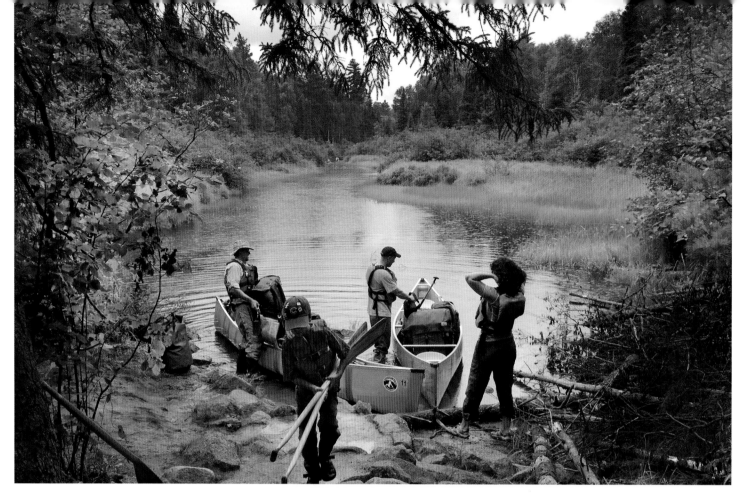

ONE TRIP, OR TWO? *Paddlers unload on the Nina Moose River, Boundary Waters. Whether to travel light and portage in a single trip or to bring more comforts from home define two approaches to canoe country travel.*

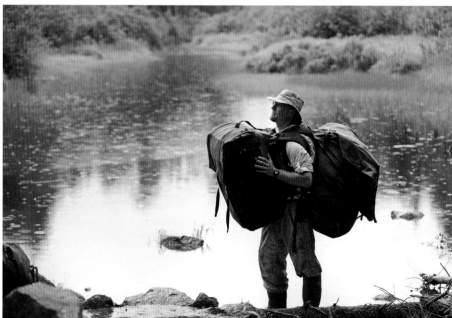

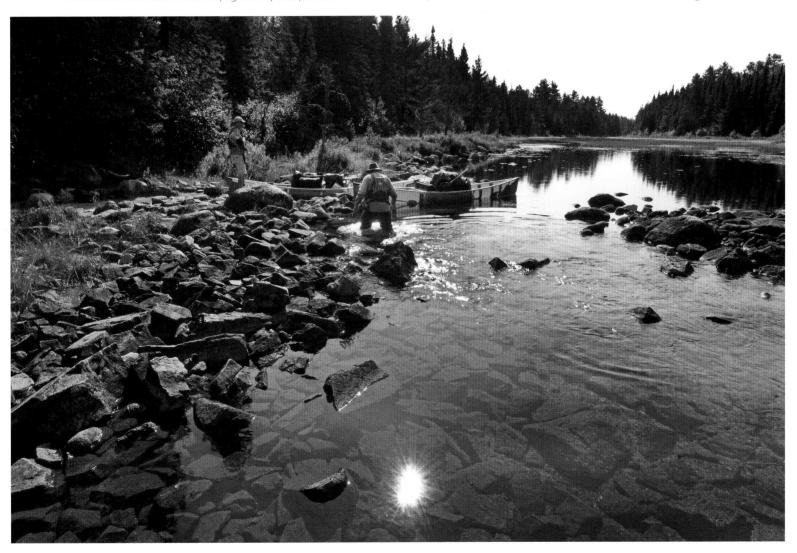

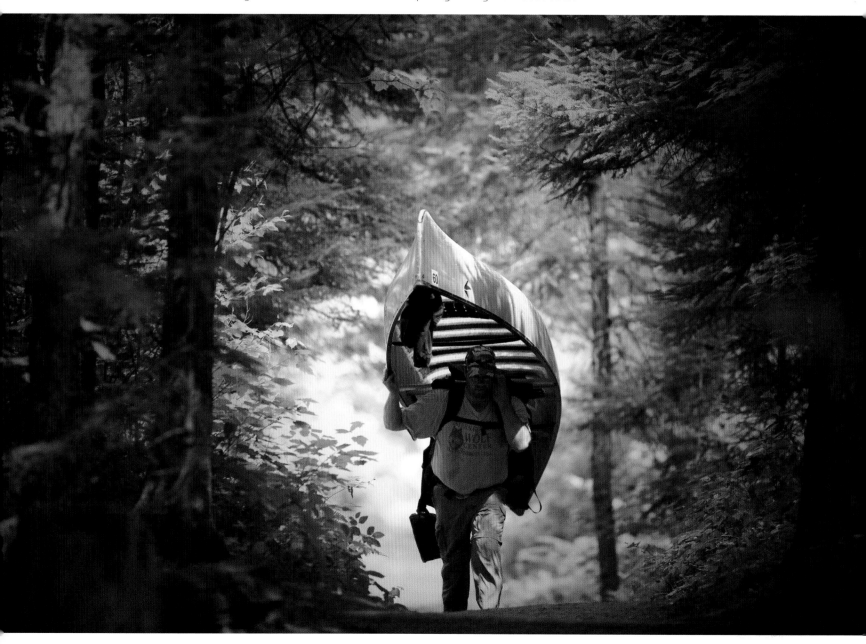

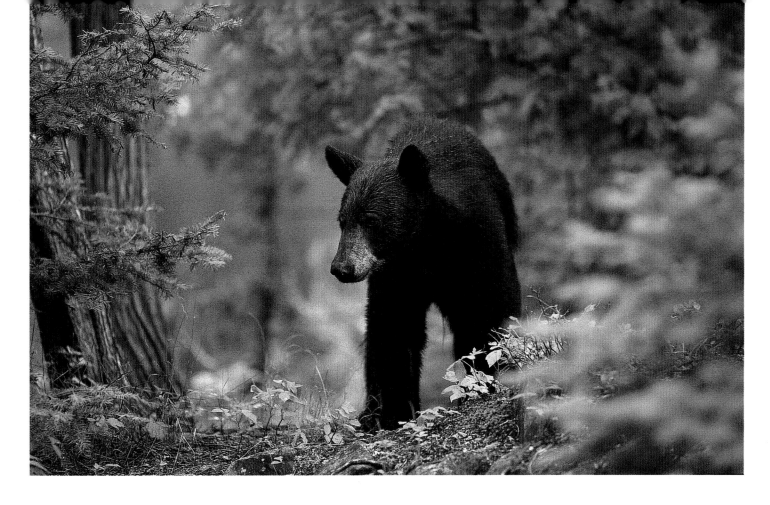

SHARING THE TRAIL. *A black bear and harebells*

THE PORTAGE

PHILOSOPHY OF FOOTWEAR. *Whether you prefer the Zorro-mark of the sandal tan or the support of a pair of hiking boots, the result is often the same—scraped knees and muddy feet.*

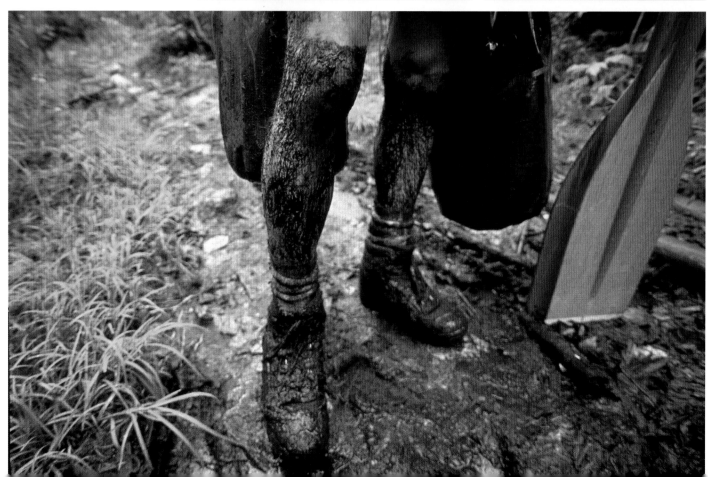

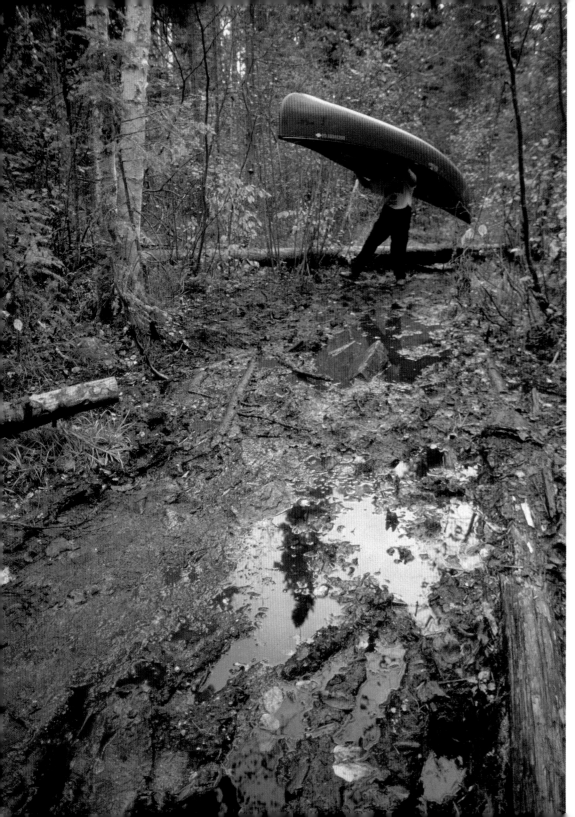

FOOTSTEPS OF VOYAGEURS. *The nature of portaging hasn't changed. According to historical geographer Ralph H. Brown, "the portage paths around falls or between rivers were likely to become gutters of mud in rainy weather."*

59

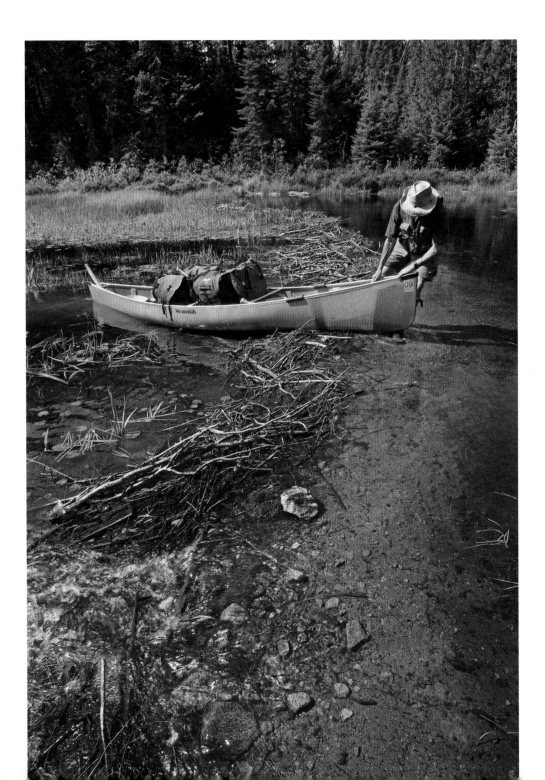

**DAM BEAVERS!** *Beaver dams hinder passage on narrow streams but may also raise water levels enough to ease navigation. Here, hard work on Bass-wood Lake.*

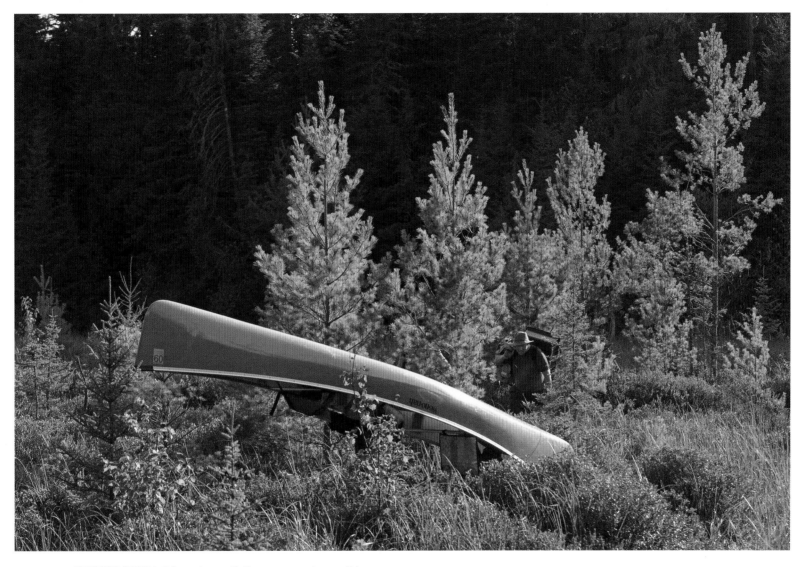

BOGGED DOWN. *When the trail disappears, stop walking.*

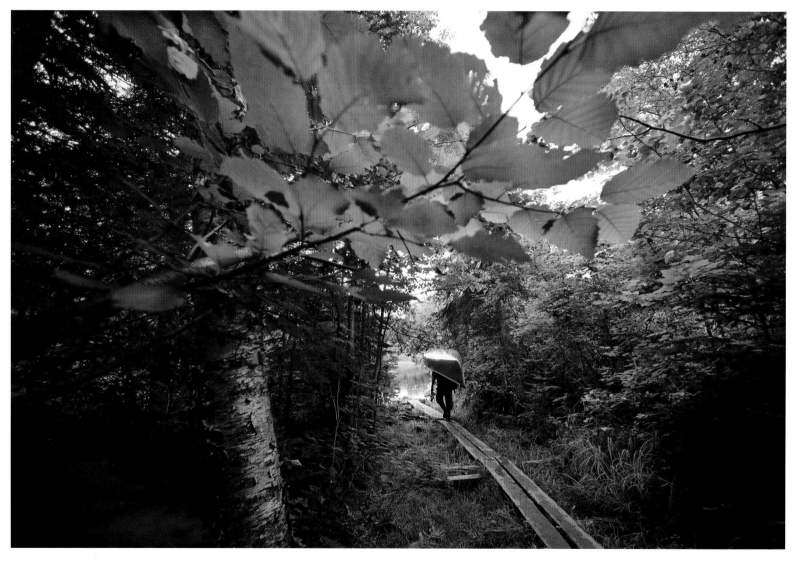

**LUMBERING WITH A LOAD.** *Boardwalk planks to Nina Moose Lake*

ARMIN LAKE PORTAGE *to Yum Yum Lake, Quetico*

# a load to carry

**The great advantage of a canoe over other craft:** its light weight on the portage trail.

- ▸ 36-foot birch-bark Montreal canoe: 600 pounds, carried by four voyageurs
- ▸ 25-foot bark north canoe: 300 pounds, carried by two
- ▸ 13-foot bark "hunting" canoe: 45 pounds
- ▸ 17-6 Fletcher wood-and-canvas "Bill Mason" heavy-duty tripper: 85 pounds
- ▸ 17-foot Alumacraft Quetico standard weight: 69 pounds
- ▸ 18-6 Bell Northwoods "Black Gold" composite: 51 pounds
- ▸ 16-6 Wenonah Prism solo graphite ultra-light: 31 pounds

---

**During the heyday of the Montreal fur trade (about** 1779–1820], canoe brigades traveled a route from Lachine [near Montreal] by several rivers to Lake Huron, through Sault Ste. Marie, and into Lake Superior. At Grand Portage, they transferred loads into lighter canoes and continued through what is now the Boundary Waters–Quetico, and then northwest to Fort Chipewyan on Lake Athabasca. In all, depending on water level, the route required about 120 portages.

---

**Stephen Bonga, an African American trader in charge** of the American post on Basswood Lake in the early 1800s, boasted of having toted eight packs across a portage in a single carry. At ninety pounds apiece, that's 720 pounds. Typically a voyageur by contract would be responsible for carrying 540 pounds in three crossings.

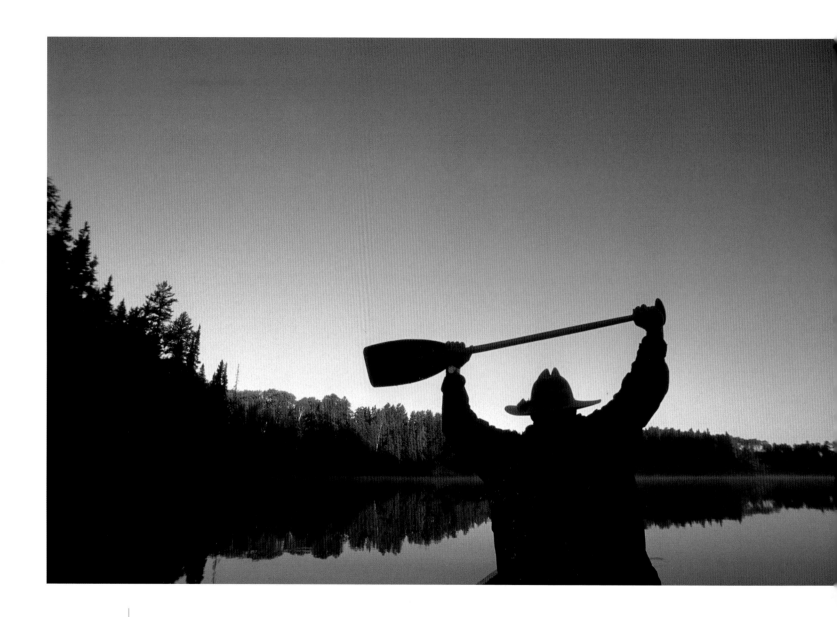

PADDLING A LINE. *Reaching Maraboef Lake, though which the international border runs*

# VI ❧ An Imaginary Line

THE BORDER BETWEEN THE UNITED STATES AND CANADA is considered the longest nonmilitarized international border in the world. It stretches more than 5,500 miles without machine-gun nests or razor wire. Nothing like the border between, say,

Russia and Finland, with an ecosystem similar to canoe country but a different history. There, a hundred meters of forest have been cleared of birch and spruce and replaced with gates, bunkers, and observation towers brandishing high-intensity searchlights. Here, in the *bush,* as our neighbors to the north would say, the border is cleared for three meters on each side or not visible at all.

In many ways the border is an imaginary line. It follows no mountain range, no single major river, nothing obvious to the eye. In terms of landmarks, it barely exists. Yet it exerts its influence. The border has created two different wilderness areas where, for millennia, humans had seen only a seamless sprawling landscape.

The border between Minnesota and Ontario has its origins in the fur trade. The Treaty of Paris ending the Revolutionary War established a boundary between U. S. and British possessions that ran through the center of the Great Lakes and westward from Lake Superior along the customary water route. Negotiators thought this meant up the Pigeon River and along the string of lakes that voyageurs followed to points north and west. But the treaty makers made a mistake. They failed to realize that the last twenty miles of the Pigeon River was filled with unnavigable white water and that fur traders bypassed these falls and rapids by using the portage to the south. Through this error, the treaty handed the British fur trade post at Grand Portage and the portage itself to the Americans.

The Webster-Ashburton Treaty of 1842 ironed out some remaining ambiguities so that "all the water communications, and all the usual portages along the line from Lake Superior to the Lake of the Woods; and also Grand Portage, from the shore of Lake Superior to the

NORTH OF THE BORDER. *Kahshahpiwi Lake, Quetico* ⟶

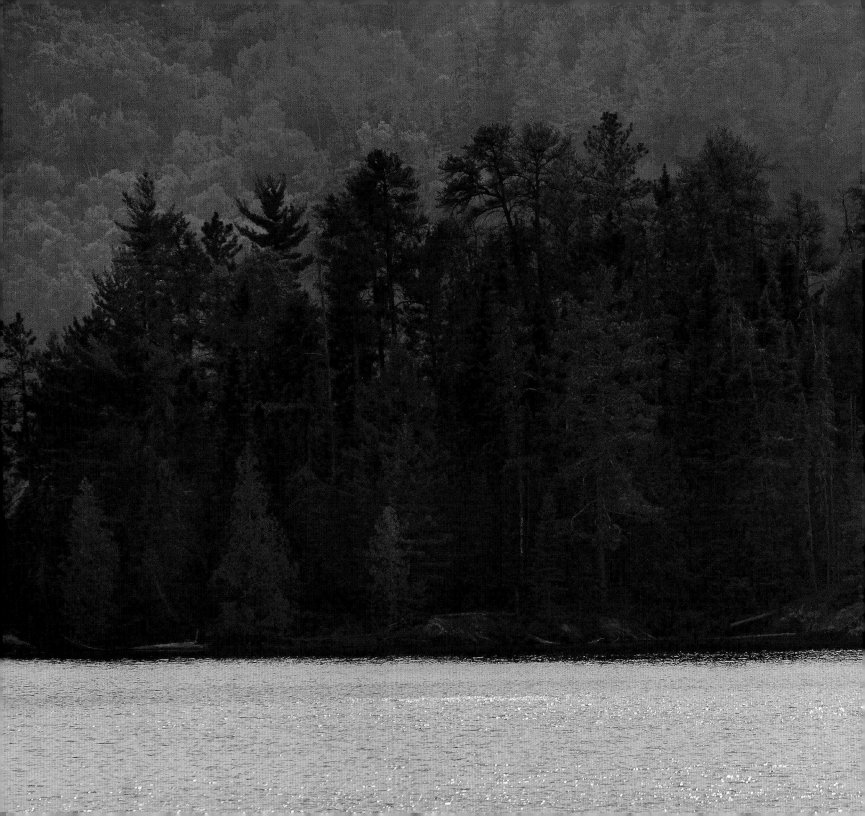

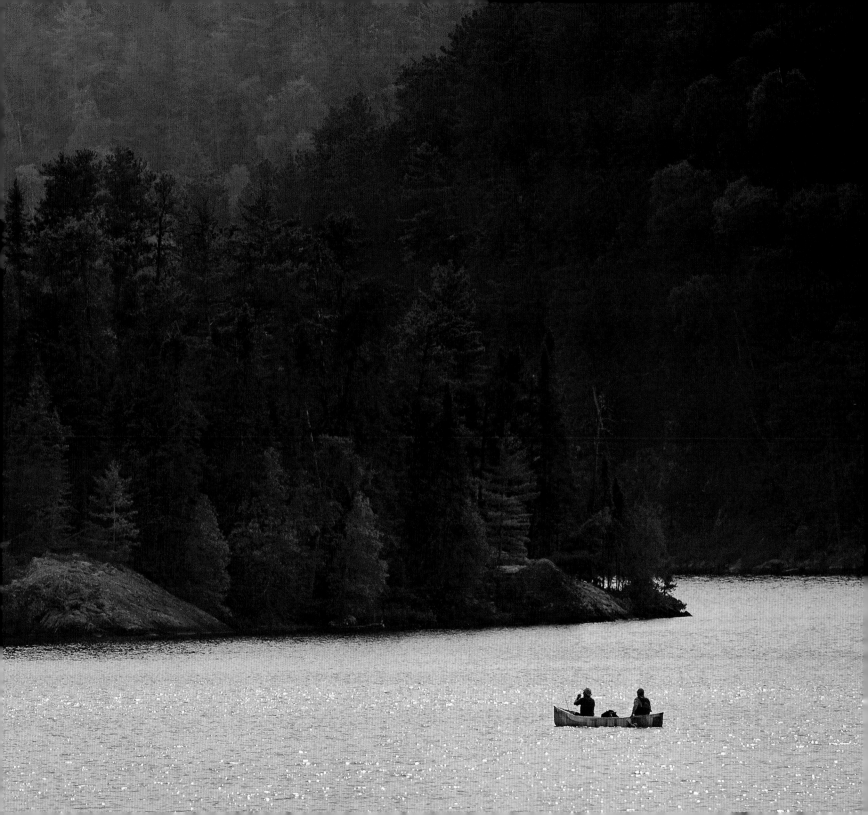

Pigeon river, as now actually used, shall be free and open to the use of the citizens and subjects of both countries." And so it is. The border, stretching from Lake Superior westward through canoe country to Rainy Lake, about 200 miles by water, follows sequences of lakes and rivers joined by more than thirty portages. If you were to paddle the route, you might portage first to one side and then the other. Without a map, you would never know that a border exists or whether, at the moment, you paddled or walked in the United States or in Canada.

<center>∽</center>

GEOGRAPHICALLY, THE BOUNDARY WATERS Canoe Area Wilderness and Quetico Provincial Park are nearly indistinguishable, each a mosaic of rock, water, and forest. The Canadian wilderness has fewer but larger lakes. Many are narrow and trend east to west. In calm weather, it is possible to glide joyfully mile after mile without a portage, but a strong west wind will keep paddlers in camp for days. Quetico, being slightly farther north, seems rockier, more coniferous, moosier—more *boreal*. In fact, however, the greater change runs not from north to south but from the warmer, drier western side of the wilderness to the cooler, moister eastern side.

Nonetheless, the two areas south and north of the border are remarkable for their similarities. Although lumbered for red and white pine in the past, they were first set aside for preservation in 1909—the Quetico as the Quetico Forest Preserve, the Boundary Waters as part of the new Superior National Forest. They are of similar size today—the Boundary Waters at 1.1 million acres, the Quetico at 1.18 million acres. Together they are larger than Yellowstone National Park. Both are treated largely as "wilderness," with no logging, no mining, and a minimum of motorized traffic and human development.

Yet, the existence of the invisible line between them has created two areas with different characters. The prosaic if descriptively named Boundary Waters contrasts with the poetic *Quetico,* origin unknown but most appealingly described as an ancient Ojibwe word for a spirit that lives in places of great beauty. Hunting is allowed in the Boundary Waters, but not in the Quetico. The Ojibwe of Lac la Croix are allowed to fly fishing clients into part of the Quetico, but no flights are allowed

into the Boundary Waters. Quetico park managers may intentionally set a fire to mimic conditions of natural wildfire; Boundary Waters managers generally will not.

But here's the biggest difference: Though both areas are nearly the same size, ten times as many people use the Boundary Waters. That leaves the Quetico seeming wilder and lonelier.

What accounts for this difference in visitors? Accidents of geography and history created several cities on the U.S. side of the border, including Minneapolis and St. Paul, Milwaukee and Chicago. Except for Winnipeg, no Canadian city of similar size exists within 600 miles. So, not surprisingly, it is Americans who make up three-quarters of the visitors to the Quetico.

What keeps Americans from invading the Quetico in the same numbers that they use the Boundary Waters? To a small degree, it is distance. To reach the Quetico simply requires paddling farther and portaging more often, or driving farther, into Canada, to enter from the north.

But travel is not the principal reason canoeists stop at the border. The real reasons are red tape and higher fees. To travel from the Boundary Waters into Quetico means additional paperwork to enter a second wilderness. It also requires a remote border-crossing permit into Canada and a passport. Quetico also charges higher fees, especially for Americans. And anglers must buy more expensive nonresident fishing licenses.

Author and former Quetico naturalist Jon Nelson is alarmed at the cost of camping in what he calls "the wilder twin." The fees discourage families with kids and canoeists from youth camps—the very people who are likely to become the canoe country enthusiasts and conservationists of tomorrow, at a time when participation in the outdoors isn't growing.

But these barriers to reaching Quetico provide some rewards to those who make the effort. With fewer anglers, the fishing is arguably better. And with fewer visitors, Quetico managers haven't felt the need to assign campers to sites and tent pads. You may pitch your tent anywhere you want. People with skills and good sense pick the same places the Indians did—a site with a flat surface for sleeping, a landing for the canoes, and exposure to favorable breezes to clear out bugs.

In the crowded Boundary Waters, where campers dutifully pitch tents only at designated sites, competition

gets fierce toward the end of a midsummer's day. Once, paddling toward Malberg Lake, my young daughter and I were drenched by an afternoon thunderstorm and began looking for a camp. The first we saw was low and marshy, and we passed it by—a mistake, it turned out. The next several were taken by other canoeists. Finally, we paddled into a back bay just as another canoe emerged, occupied by three young men. That could only mean the site was already claimed—by them or someone else.

"Taken?" I asked without much hope.

"Yeah, by a big black bear in the middle of the campsite," one man said. I laughed. "We're not kidding."

But we were nearly desperate for a camp. After consulting the map and realizing we had few other sites we could reach before dark, we set up our tent, even though it meant having to chase the bear back into the woods before we cooked dinner.

The first day on a recent trip to the Quetico with my wife, I fell into my old habit, anxious by mid-afternoon, despairing of finding a site before dark. It hadn't helped that rain had fallen all day and another downpour threatened. We found a small clearing along a rocky shore. There was no rock fireplace or sign of a campfire. Someone had been there in the past, beating down the underbrush and a footpath along shore, but probably not that summer.

From then on I realized our good fortune and began to relax. During the next several days, we paddled the rangy lakes of Quetico and Cirrus, so long and narrow and cliffy they stretched on like river gorges. We paddled in rain and sun. We fished when we felt like it and hiked to see the high, broad cascade known as Sue Falls. We had no need to hurry, no need to worry that a campsite would be taken. We could camp anywhere the ground was flat and the shoreline permitted a canoe to land. And from what I was seeing, these places abounded on every shore. Free from my concern with finding a tent site, we enjoyed the advantages of exploring the wilder twin. ❧

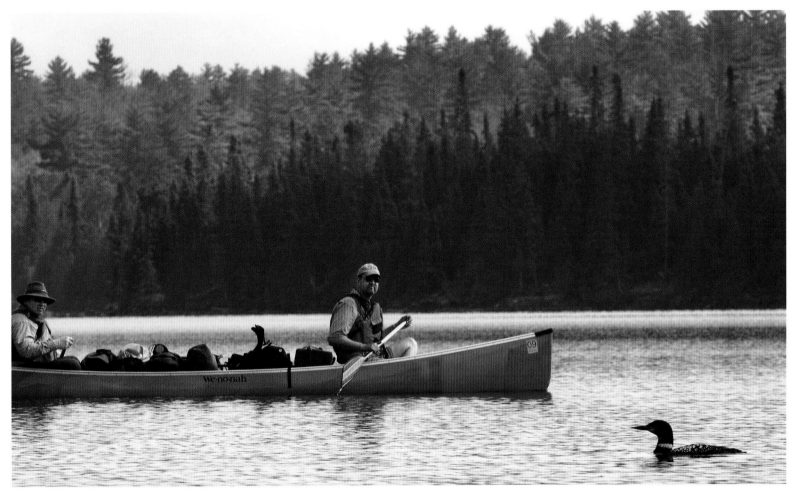

**NORTHWARD TRAFFIC.** *Most wilderness travelers in the Quetico are U.S. citizens. The loon? Hard to say.*

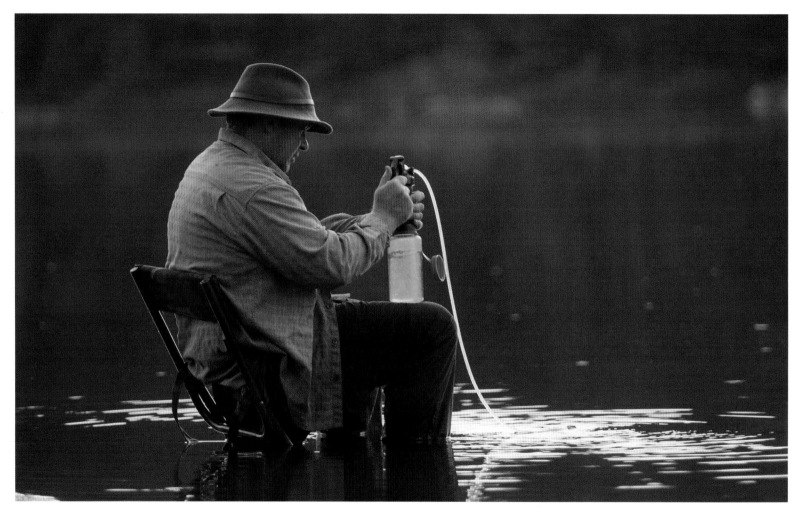

ISOLATED WATERSHED. *Both Quetico and the Boundary Waters are far from most sources of pollution. Even so, many campers filter water to strain out giardia, the protozoan cause of so-called beaver fever, a gastrointestinal illness.*

**FRESH FOOD.** Voyageurs ate corn mush, perhaps wild rice, and even maple syrup. Today's canoeists carry fresh food if they're willing to portage it, or travel fast and light with dehydrated and freeze-dried camp foods.

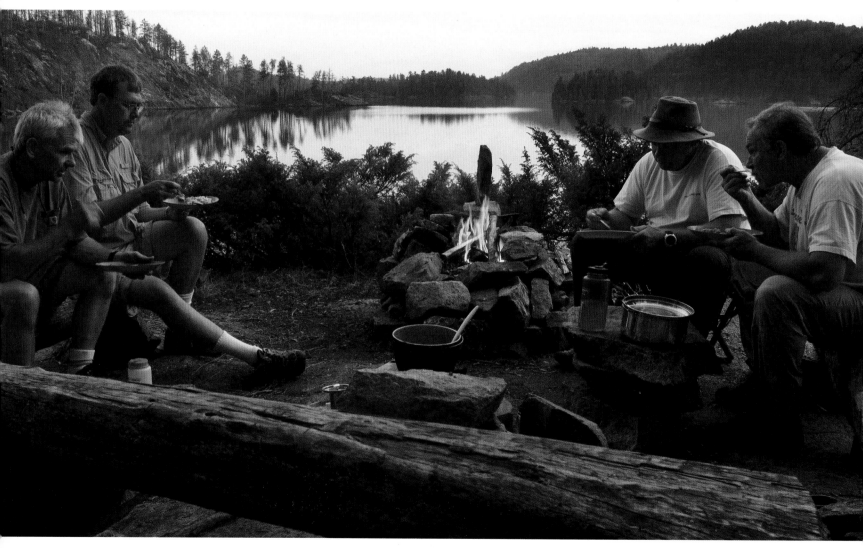

SUPPERTIME, *Kahshahpiwi Lake, Quetico*

74

*PADDLE NORTH*

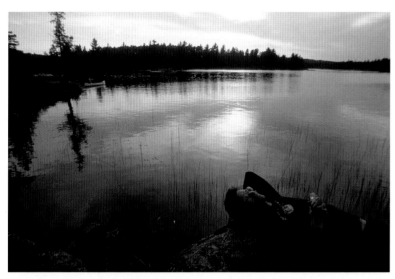

DAY'S END. *Wet Lake, Quetico; Perseid meteor showers and Milky Way, Lac la Croix*

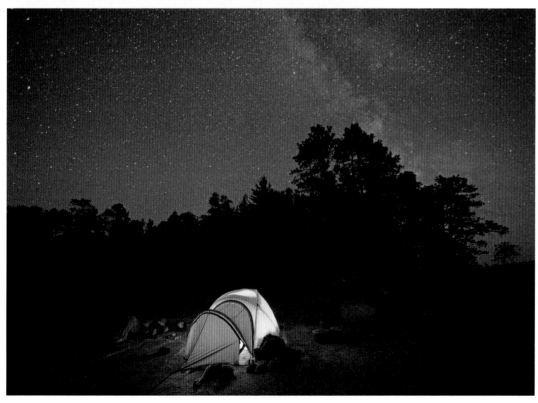

SUMMER CLOUDS. *Grey Lake, Quetico* →

## a border runs through it

**Americans taking a Quetico trip will spend more for** camping fees and fishing licenses than they would in the Boundary Waters. They'll also need to plan in advance to get a remote border-crossing permit. They can pick one up in person at Fort Frances or Pigeon River or apply by mail and wait up to a month. Here's an alternative: drive through customs into Canada and enter Quetico on the north side of the park.

---

**Black bears are a particular problem in the heavily** used campsites of the Boundary Waters but can plague campers in Quetico as well. Conventional wisdom says hang food packs from trees. Canoe guide and author Cliff Jacobson disagrees. "Bears climb trees, and they climb very well," he says. His advice: stash the food pack for the night back in the woods, far from the trails and shorelines bears routinely travel.

---

**Fort Charlotte was located at the west end of the** Grand Portage, on the Pigeon River. Researchers in scuba gear have recovered brass teapots, early French ceramics, and wooden canoe parts in the mucky river bottom.

---

**The fur trade trafficked not only in furs, manufactured** trade goods, and liquor but also in human captives. African slaves accompanied their owners to posts. Indian slaves, including women and children, were bought and sold. John Askin, the commissary at Mackinac, wrote to the clerk at Grand Portage: "I need two pretty Slave girls from 9 to 16 years old. Have the goodness to ask the Gentlemen to procure two for me."

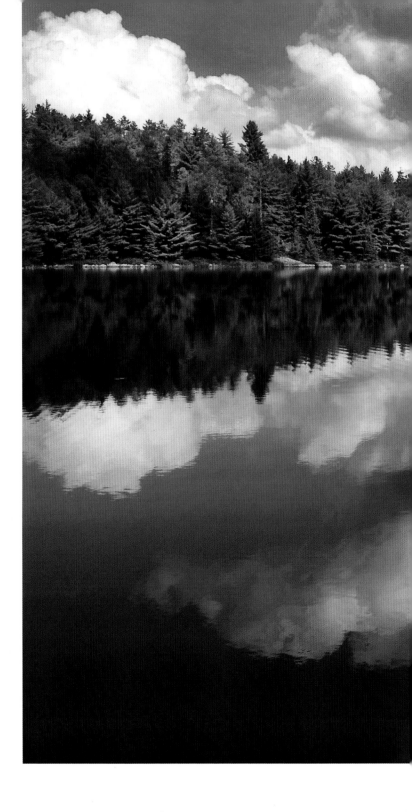

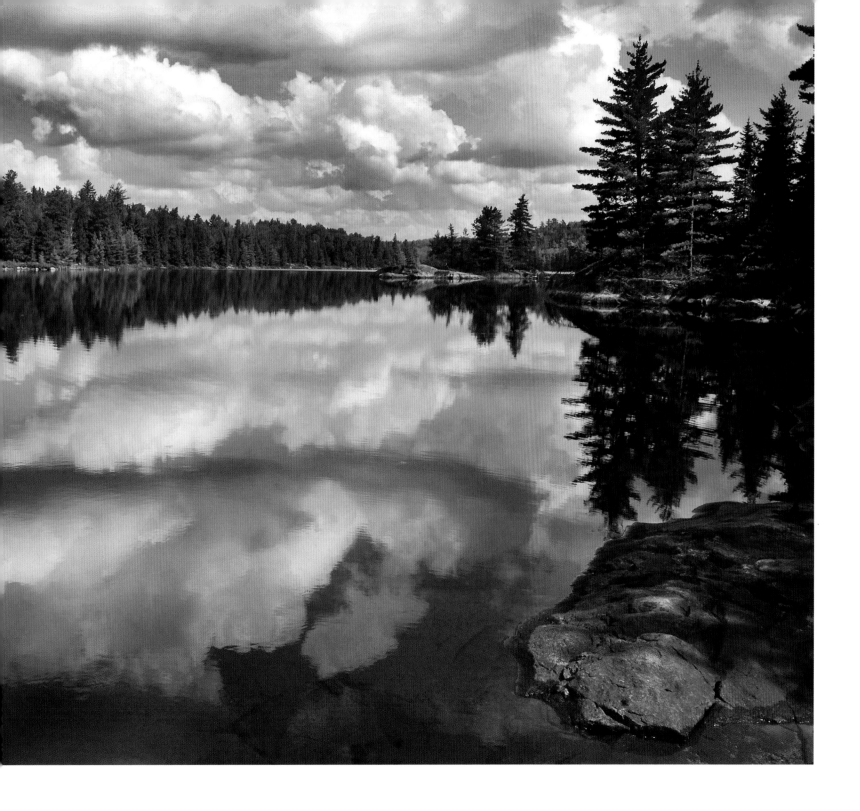

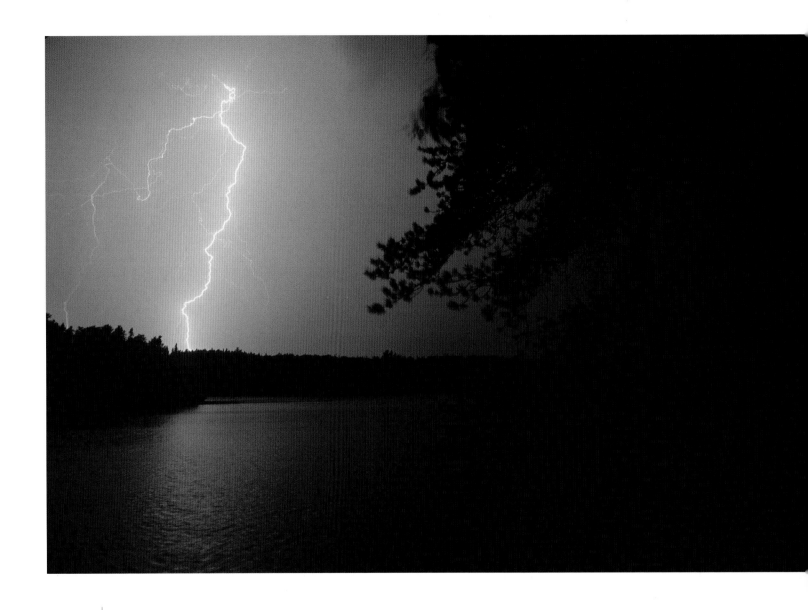

 LIGHTNING STORMS *and also humans have ignited canoe country forest fires over thousands of years.*

# VII ❧ FOREST PRIMEVAL

ENVIRONMENTALISTS AND WILDERNESS ADVOCATES, more so perhaps a few years back than now, toss off clichés such as "forest primeval" and "time immemorial"—phrases that suggest something has existed or might exist

virtually unchanged forever. Indeed, walking into a stand of giant pine, each four feet across at the base, or into a grove of ancient white cedars wading in a pool of cool shadows, one can easily imagine that the scene sprung up at the dawn of creation and might endure till the end of time.

But such delusions can't stand up to the scrutiny of forest ecologists. More than a half century ago, Swedish ecologist Magnus Fries had begun studying the charcoal and pollen buried in north-country lake sediments, noting that the muck at lake bottoms revealed the fire and forest history on the surrounding landscape. Scientists at the Universities of Minnesota and Wisconsin duplicated this work in the nearly pristine lakes of the Boundary Waters. Layers of charcoal showed that fire played a nearly continuous role

in the evolution of the forest since Ice Age glaciers melted back more than 10,000 years ago.

The story of Minnesota's northern forests has been written by fire. Among the most comprehensive and detailed studies of the area's fire history is the work of Miron "Bud" Heinselman, an ecologist with the U.S. Forest Service from 1948 to 1974. Soft spoken, with a face as round and pale as the full moon, Heinselman laboriously cruised the Boundary Waters, boring into the trunks of standing trees and pulling cores to count annual rings and look for signs of fire scars. From thousands of cores he determined when catastrophic fires swept the land and cleared a seedbed for a new stand of trees. Scars on fire-resistant pine told when minor ground fires consumed fallen debris and killed fire-sensitive balsam fir and aspen. On average, Heinselman found, a given

acre of the Boundary Waters burned once a century. Vulnerable ridgetops burned more often; shorelines and swamps much less frequently, if at all. "The landscape-vegetation mosaic is like a giant kaleidoscope, with fire being the principal force that periodically rearranges the patterns of vegetation types," Heinselman wrote. "In turn, these vegetation patterns largely determine the habitats available to all land-based wildlife."

In the days before computers were common, Heinselman translated his data onto number-coded fire-history maps that showed the dates of origin of nearly every stand of trees in the Boundary Waters. A protégé, Lee Frelich, remembers watching Heinselman spread out the maps at his Falcon Heights home, crawling over couch and coffee table to lay out the entire wilderness in his living room. "It was like playing a game of Twister," Frelich said. "It was a great time with Bud, no matter what you were doing."

On one occasion Heinselman and Frelich traveled up the Gunflint Trail to the Boundary Waters and paddled to Three Mile Island in Seagull Lake, where Frelich would continue some of Heinselman's pioneering work. Not long after, Heinselman fell ill, and Frelich remembered a day in 1993 when Heinselman came by to talk about his work—for two straight hours. When Heinselman died a few days later, Frelich realized he had been "telling me everything he knew about the forest in the Boundary Waters." Today Frelich is a research associate and director of the University of Minnesota's Center for Hardwood Ecology. Best described as a "disturbance" ecologist, he studies the disruptive forces that affect the form and function of our forests.

We often think of these disturbances as catastrophes, disasters, even tragedies. Some are natural, such as forest fires set by lightning. Some are man-made, such as logging, which was common in the Boundary Waters and Quetico through the early twentieth century.

And other disturbances—well, it's not clear if they're *natural* or not. Native Americans set fires to clear out underbrush and create more browse for game animals. Ferocious windstorms have cleared thousands of acres—the effect of nature, or human-caused climate change? Deer are changing the nature of the canoe

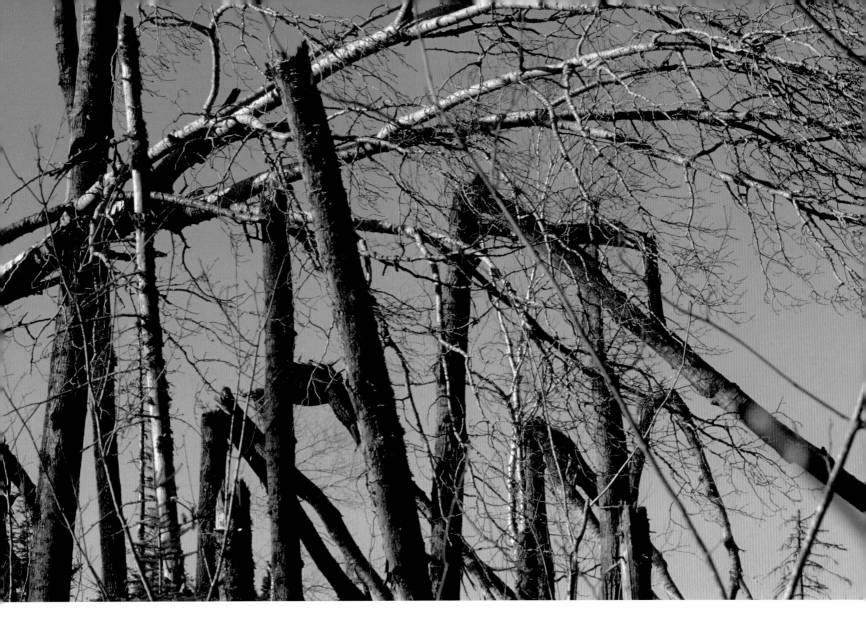

WINDSTORMS, *such as the infamous 1999 blowdown that damaged 500,000 acres, have reshaped the northern forest.*

country forest by chomping white pine and northern white cedar, but the animals wouldn't be there if not for logging and road building. And there's the biggest disturbance of all—global climate change, a natural response to human actions.

⌀

FRELICH WAS A FEW YEARS INTO HIS RESEARCH on Three Mile Island, studying how 200-year-old pines give way to other species, when a funny thing happened. On July 4, 1999, his laboratory blew down. A freakish windstorm with gusts to nearly 100 miles an hour leveled twenty-five million trees in a third of the Boundary Waters, a thirty-mile-long swath reaching northeast almost from Ely to the end of the Gunflint Trail. In places, trees were flattened as far as the eye could see. Deadwood formed a tangled, well-ventilated mat so deep a person could stand on a horizontal trunk and yet be twelve feet above the ground. Among the casualties were most of the mature trees on Three Mile Island. Said Frelich, "Our old-growth study became a blowdown study."

In 2007 the forest drama continued, but this time Frelich had a front-row seat. In early May, shortly after ice-out, he had paddled into the Boundary Waters to tramp around some of his research sites with two companions (including Layne Kennedy, whose photographs appear in this book). At midday they noticed a dark plume to the south. Within two hours, smoke filled the sky, and they fled to the north shore of Seagull Lake. Through the day the wind rose, not only fanning the flames but churning up large waves that pinned the men in their campsite. The water was ice cold, and they dared not risk capsizing.

For two days they sat in camp as the firestorm known as the Ham Lake fire crept within just a few miles. On the second night, the light from the fire was so bright they could walk around the woods without a headlamp. Climbing the high cliffs of the lake, they watched a monstrous fireball in the east, and Frelich knew that the historic Wilderness Canoe Base camp near the end of the Gunflint Trail had gone up in flames. Only after the wind died—thankfully, before fire reached them—were they able to escape down the Seagull River.

A YEAR AFTER THE FIRE, I SLIPPED my lightweight canoe into Seagull Lake and tossed in a rain jacket, drinking water, and a map. Frelich plopped into the bow, and we paddled west toward Three Mile Island.

"I've never seen the lake this calm," Frelich marveled, noting the marked contrast to the horrendous whitecaps of a year earlier. Much of the shore had been burned down to pink granite. Charred tree trunks stood like poles. Others lay scattered among the tangle of verdant new growth, including Bicknell's geranium and large-leafed aster. White-throated sparrows sang constantly: *O, Sweet Canada, Canada, Canada*. A pileated woodpecker flew over a channel.

We landed on Three Mile Island, in a rocky pocket where an attentive hen mallard watched her brood of five ducklings. We hiked the shoreline to a small grove of surviving cedars that ranged in age from 550 years to as old as 1,000 years. On this moist, sheltered shoreline, the trees had survived a montage of fires.

When Frelich first came here, the island was a jungle of balsam fir, with a cohort of red pines dating from a forest fire in 1595. All that is gone. The balsam burned, and the last of the red pines were killed by lightning. In places, the decayed forest duff had burned clear down to pink granite. But elsewhere we clambered over downed logs and waded through thriving birch saplings, fireweed, currants, and ripening blueberries. Frelich pointed out creeping snowberry and tiny seedlings of red pine and cedar. Buried seeds of pin cherry may have survived 200 years, only to sprout when they saw the sun after the ground cover and leaf litter burned. "It's not easy walking," he said. I agreed.

As we reached higher ground, Frelich described the waves of destruction and rebirth. On the way in, he reminded me, we had paddled past the charred remains of the 2007 Ham Lake fire that had kept him in camp for two days. At the moment, we stood amid trees leveled by the 1999 windstorm and cleaned up in a 2002 prescribed burn intended to reduce fire danger. Along an adjacent shoreline, vigorous young stands of trees grew in the remains of the Roy Lake fire of 1976. And there, said Frelich,

pointing westward down the lake, where the islands and shoreline fairly glowed pink from exposed granite, was the site of the intensely hot 2006 Cavity Lake fire. And beyond that, at the far end of the lake, were the remains of the Alpine Lake fire in 2005. And what of the old forest of pines and other species that somehow escaped these fires? Most, said Frelich, grew in the aftermath of a huge fire in 1801.

We paddled to nearby Eagles Nest Island to see results of the Cavity Lake fire, which had scorched much of the island to clean bedrock. Exposed, baked roots wrapped around outcrops like fingers. Red pines stood tall, many of them dead. Yet much of the ground was green, quickly being reclaimed by birch and fireweed. A moose, undoubtedly foraging the new growth, left behind a pile of turds.

On Miles Island we climbed a steep rock escarpment. As we dodged the spike-like branches of burned spruce and tripped over bindweed, Frelich continually remarked on the appearance of red maple, a species that until recently had been held at bay by wintertime cold. He recounted the dieback of birch trees due to too-warm soils. He noted the

spread of species coming from elsewhere, including earthworms, which reengineer the soil, consuming loose organic "duff" to the detriment of native wildflowers. (Whatever native earthworms existed here disappeared long ago beneath glacial ice.)

On this sweltering July day, sweat poured from under Frelich's floppy sun hat. "What will the Boundary Waters look like in a century?" I asked. "With unmitigated global warming—and that's probably what we're going to have, say it warms up in the summer by four or five degrees Celsius—I'd expect it to be a lot more shrubby." Signature jack pine, red pine, spruce, balsam fir, and even paper birch might all but disappear. White pine and northern white cedar might endure, but only if abundant deer don't munch their seedlings to nubs. Some areas could evolve to bur-oak savanna. In others, red maple and oak might form a hardwood forest.

By Frelich's reckoning and the assessments of other ecologists and climate experts, the Boundary Waters will change. Within a century, one of the last, best examples of the great north woods will look like, well, perhaps the forest of southern Iowa. Southern

Iowa may have its virtues. But to me, or anyone else with a love of canoe country as it appears today, such a scenario sounds genuinely apocalyptic.

We looked down at a fleet of canoes heading east out of the wilderness. The paddlers, unaware we stood on the cliff above, sang "The Star-Spangled Banner"—loudly and out of key. A white-throated sparrow also sang, pitch perfect, its ode to Canada.

Though Frelich occasionally veers toward the apocalyptic himself, he easily returns to the calm objectivity of the scientist. "Everything is interesting in terms of its ecology and science," he had told me earlier. Over time, the boreal forest "has gone back and forth from Tennessee to Hudson Bay. After people are gone, new species will evolve, and on a long time scale the earth will recover just fine."

Windstorms. Lightning. Wildfire. And, for the last 10,000 years, the manipulations of a clever primate who had learned the trick of fire. Now, a rapidly warming climate. The balance of nature is a fallacy. There is no balance. No time immemorial. In canoe country, there is no forest primeval. ∽

## change—the only constant

*Extreme drought led to huge forest fires in 1863–64,* the most widespread in centuries. Nearly half of the present Boundary Waters burned.

---

*Jack pine depends on fire to prepare a seed bed and* even to open its cones. Resinous pitch seals cones shut until heated to 116 degrees. Seeds are heat-resistant, able to survive if they fall on ashes or coals.

---

*A surprising number of wildlife species, even small,* slow-moving mammals, survive forest fires. Studies of the Little Indian Sioux burn in 1971 showed that just three weeks after the fire, redback voles, chipmunks, and deer mice scurried over even the most severely burned portions of the forest.

---

*Botanists have identified 666 vascular plants in* Quetico. Most are terrestrial, and more than 10 percent are not native to Ontario.

---

*Demand for pelts drove down beaver numbers as* recently as the mid-1900s. With restrictions on trapping and the abundance of aspen after logging, beaver numbers have grown. In Voyageurs National Park, just west of the Boundary Waters, beaver ponds increased from only 1 percent of the park area in 1940 to 13 percent by 1986.

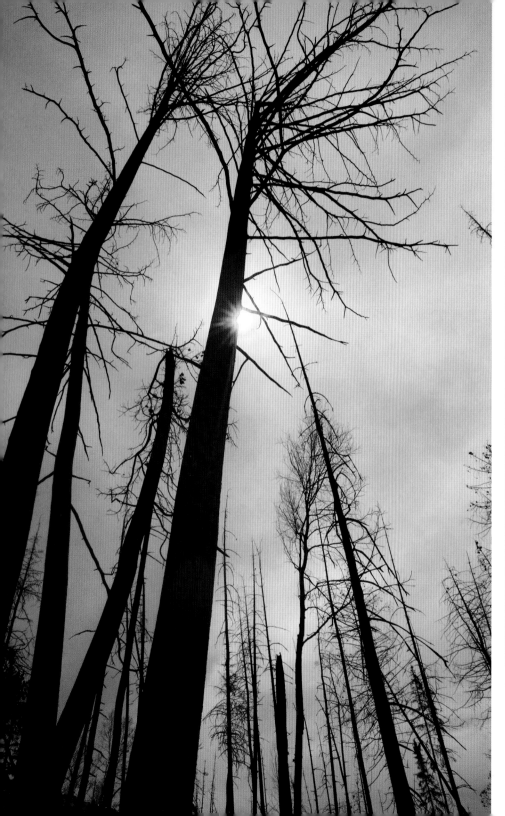

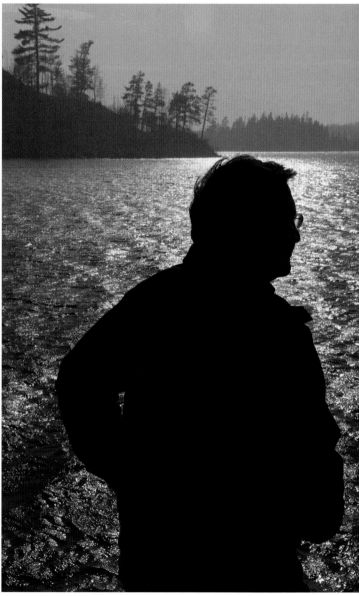

**CLOSE LOOK.** *Sheltered among charred tree trunks burned just a year earlier (left), Lee Frelich watches the advance of the Ham Lake fire.*

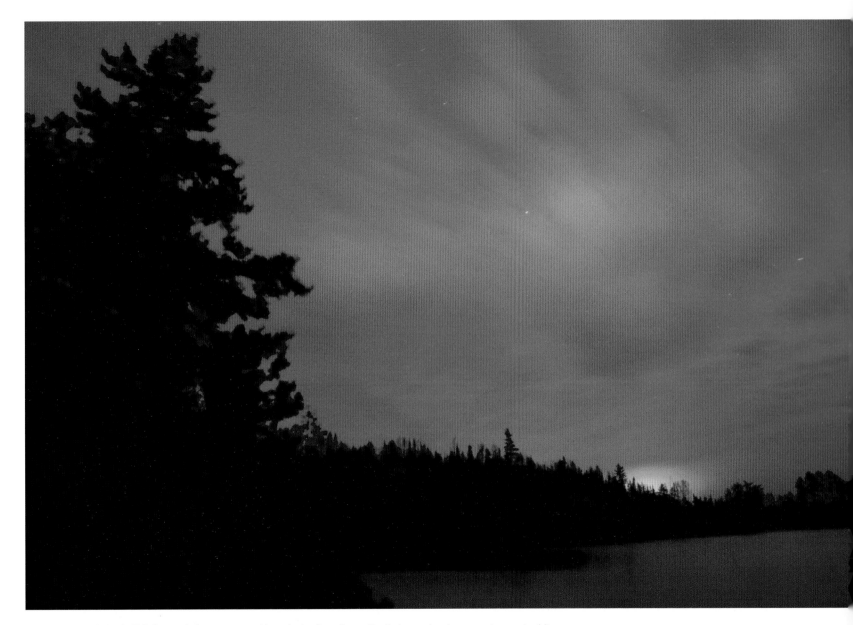

HIGH WINDS *fanned the nascent Ham Lake fire. Soon firefighters had no way to control it.*

DAY THREE. *The Ham Lake fire blackened 75,000 acres near the Gunflint Trail, on both sides of the border.*

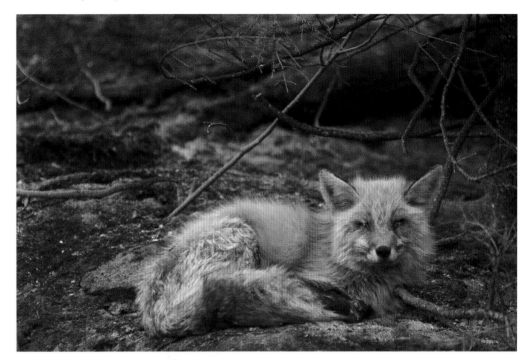

**MORTALLY BURNED.** *Unable to move on scorched feet, a red fox huddles on the forest floor. A tree (below) smolders in the aftermath of the Ham Lake blaze.*

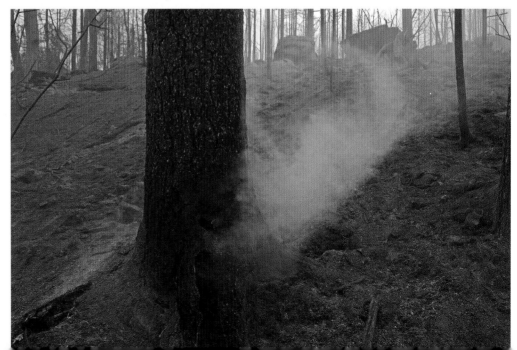

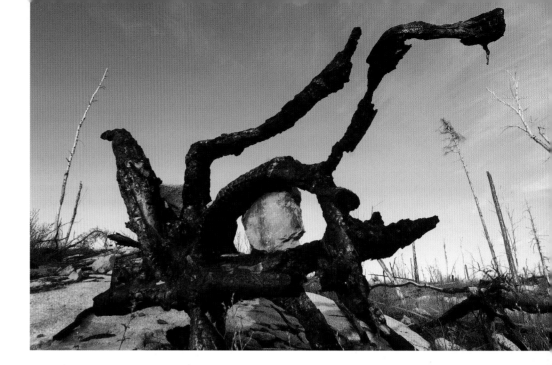

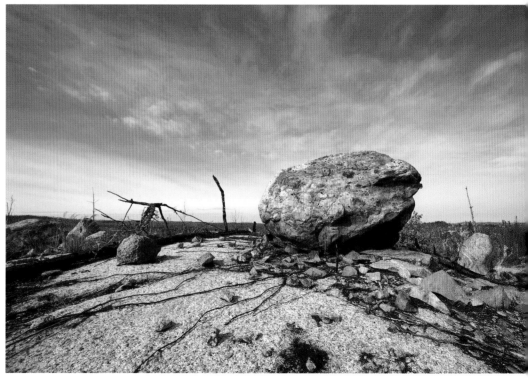

**ALL THAT REMAINS.** *Intense fires burn the forest, and even soil, to bedrock. Kevlar canoes at Superior-North Canoe Outfitters, Gunflint Trail, suffered a similar fate in the Ham Lake fire.*

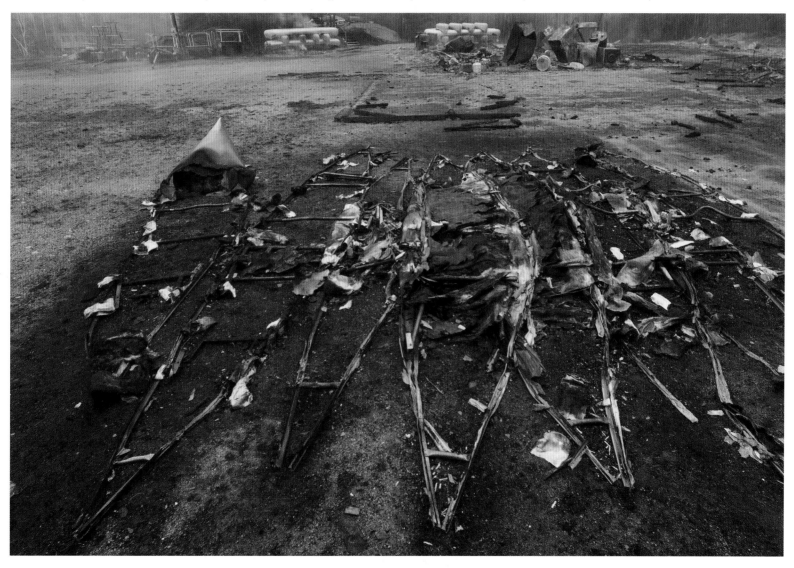

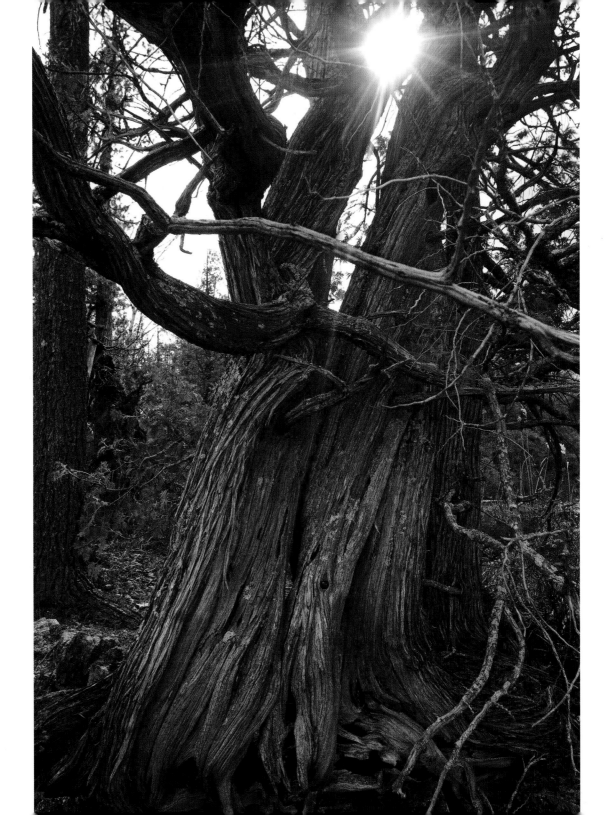

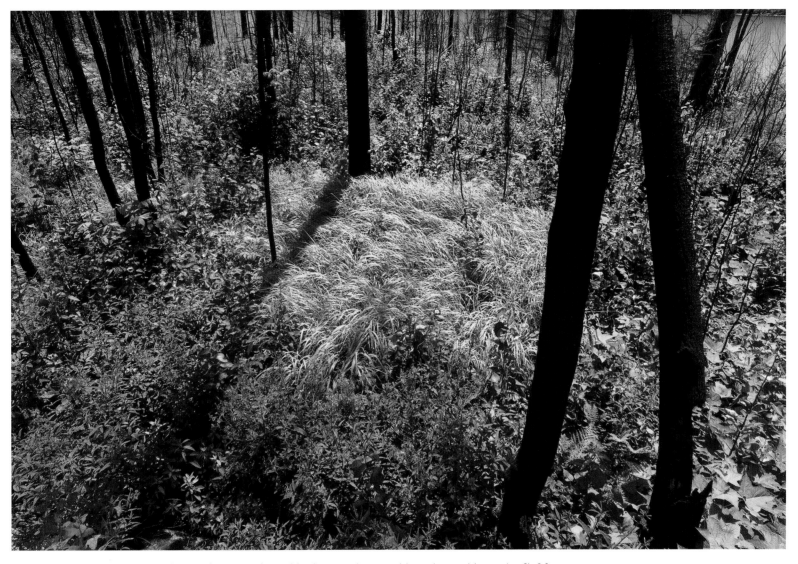

**ADAPTED TO FIRE.** *Some plants, such as this thousand-year-old northern white cedar (left) on Three Mile Island in Seagull Lake, evade fire by clinging to moist shorelines. Plants such as fireweed, blueberries, and birch and aspen seedlings (above) spring up in fire's wake.*

 FRESH SNOWFALL, *Kawishiwi River*

# VIII ❧ WINTER TRIALS

WINTER IN CANOE COUNTRY IS A SCENE OF STARK BEAUTY, painted in a palette drained of color—mounds of white on dark boughs of spruce and fir and the occasional dark lead of moving water in a snow-covered stream. Despite the low

sun and short days, winter is a season of light, of sparkling ice crystals in frigid air, of sundogs framing a pale, enfeebled sun. It is a season of signs—burrows of roosting ruffed grouse, tunnels of voles and mice, and winding tracks of snowshoe hare, moose, and even wolves.

Such is the superficial appearance of cold and snow in canoe country. But what of the more profound effects of deep winters? How does cold determine the appearance of the land and forest and what lives here? What are the most critical elements of a boreal climate—sheer cold? Long winters? Deep snow?

The questions are more complicated than they seem; the answers more tenuous. "WE REALLY DO NOT KNOW!" e-mailed one ecologist when I posed the question. Refreshing, I thought, that a world-renowned authority was confident enough to express uncertainty in capital letters.

Daytime adventures of skiing and snowshoeing may be beautiful and enjoyable at almost any temperature. I had a great time mushing a sled behind a team of Arctic-bred dogs at minus twenty-five degrees F. We raced up a creek over thin ice and skimmed open water. By the end of the day, soaked to my waist, I shed my sarcophagus of ice with a hammer.

But a single winter night in canoe country is all it takes to realize the power of cold to fundamentally influence the ecosystem. The coldest night I have camped in the Boundary Waters I estimated at minus thirty-five degrees F. Cold air cut like a razor. Food that wasn't dried froze to a solid block. During every waking moment, we were painfully aware of cold. It set down like iron, a frozen anvil of winter.

None of this comes as a surprise. The border region is renowned for relentless cold. The record mini-

mum temperature for northern Minnesota (at a site just south of the Boundary Waters) is minus sixty degrees F. On the average January night, the temperature falls nearly to minus ten degrees and during the day climbs only halfway to freezing. Maximum snow depth for the year is only moderate—usually less than two feet on level ground. But, on average, snow blankets the land beginning in mid-November and lasts for five months.

The most obvious signature of cold is the coniferous forest itself, the iconic assemblage of spruces, firs, and pines we call *boreal.* Conifers' tough needles retain moisture in the desiccating cold. When longer days arrive, the trees are ready to begin photosynthesis. Deciduous trees, shedding leaves in fall and growing leaves anew in spring, struggle to compete. Trees such as sugar and red maples barely creep to the southern edge of canoe country, apparently limited by severe minimum temperatures. Old maples at this northern limit are stunted, trunks fissured with frost cracks. Younger maples, today growing in a warming climate, have escaped unscathed.

IT IS THE COLD THAT MAINTAINS the rock outcrops and clear lakes of canoe country. Ice Age glaciers once invaded these northern latitudes and left a legacy of scarred bedrock and heaps of boulders. The coniferous forest that followed produced only a fraction of the nutrients of a deciduous forest with its annual load of fallen leaves. The cool climate inhibits the breakdown of nutrients that do exist. Soil builds slowly. The thin soils leave much of the rock barren. The slow breakdown of organic matter contributes to the formation of vast bogs of undecomposed peat, another characteristic of the boreal forest.

Just as soils lack fertility, so do the lakes that gather the runoff. With few nutrients, lakes support little growth of microscopic algae and plankton, remaining clear many feet down. With little organic material to break down and consume oxygen, lake trout and whitefish thrive in deep, cool, well-oxygenated water.

Finally, the very fact that soils are thin and infertile is one reason we can even talk of a canoe country wilderness, rather than a lake-studded farmland like that of west-central Minnesota.

COLD AND SNOW SET THE STAGE for competition between emblematic animals of the north woods and species common to the south.

Canoe country lies at the ragged, shifting border between moose to the north and white-tailed deer to the south. (In fact, biologists know some wolf packs in the area to be primarily "deer packs" or "moose packs," depending on their location and which prey is prevalent.) Both moose and deer favor similar habitat: logged or fire-ravaged forests with plenty of young undergrowth for browse and scattered shelter such as conifer thickets. But why do moose live in canoe country but not to the south? Cold and snow are the key—in conjunction with wolves and a parasitic brainworm.

First the worm, *Parelaphostrongylus tenuis,* a widespread and apparently harmless parasite of white-tailed deer. The worm also infects moose, but it cripples and often kills them. Brainworm makes it difficult for moose to survive where whitetails exist in high numbers. In the Boundary Waters and Quetico, whitetails live at a fraction of the density they do farther south, so moose can coexist. What prevents deer from becoming more numerous and in effect driving out moose?

Partly, it is the forest. Moose find more to eat than deer do in a mature forest dominated by conifers. But mostly the balance is determined by cold, snow depth, and wolves. Moose have bulkier bodies that retain heat better and longer legs that carry them more easily through deep snow. Longer legs help them find food and escape timber wolves, their chief predator. Whitetails struggle when snow gets deep, so they gather in "yards." They pack down trails to find low browse and flee from wolves. But when food runs out, deer starve.

A similar snow-mediated contest exists between the bobcat, the common wild feline of the United States, and the rangy lynx, the gray ghost of the north. Canoe country sits at the nebulous border between these two closely related cats.

Bobcats and lynx are similar in size and appearance. Bobcats eat a lot of hare and rabbit, but lynx kill snowshoe hare almost exclusively. Like these hare, lynx have enormous feet with furry pads. Their "snowshoes" support twice as much weight as smaller bobcat feet. Long legs also help. When snow is deep and hare are abundant, as is often true in the boreal forest, especially north of

canoe country, the advantage goes to lynx. But when snow cover is not as deep or long lasting, the advantage belongs to the more aggressive bobcat with its more eclectic diet.

In other cases in canoe country, cold and snow account for the appearance of emblematic species only indirectly through the habitat they shape. As one moves northward, the seed-eating red squirrel becomes far more common than the acorn-loving gray. The gray jay becomes more abundant than the blue jay. The ruffed grouse of aspen forests, while still common, shares range with the conifer-dwelling spruce grouse.

These are only the most obvious and in many ways easiest to understand cases. Often, the relationships between climate, competition, and sheer competence in the cold are subtle and difficult to determine. The aspect of cold that keeps one species at bay is not the characteristic that affects another. Yet the cumulative effect is to shape the forest and community of animals we recognize today.

⌁

THE COLDEST I HAVE EVER STOOD OUTSIDE was minus fifty degrees F. I was staying with friends in a log cabin just south of the Boundary Waters. My host glanced at the thermometer and announced that the outside temperature was 120 degrees colder than inside.

So we stepped outside in our shirtsleeves and stood in the yard, watching starlight as sharp as needles. We lasted about a minute before filing back into the cabin. That was plenty. The cold was quite enough to keep me at bay, south of canoe country—at least during the winter, at least on any long-term basis. In the morning I built a charcoal fire beneath the oil pan of my car to get it started and headed south toward home.

I often marvel how humans not only lived but thrived in these winters, taking shelter in wigwams or tiny cabins, hunting, trapping, and fishing for their food and income. Indeed, I have friends today who, though firmly tethered to the civilized world, are up for a long adventure in the cold—not just skiing or snowshoeing but living in northern winters for days, even weeks, at a time. These are people who revel in the beauty of this world, for whom the cold is but a rite of passage, a warning perhaps, but not a deterrent.

They are lynx. I am a bobcat. ⌁

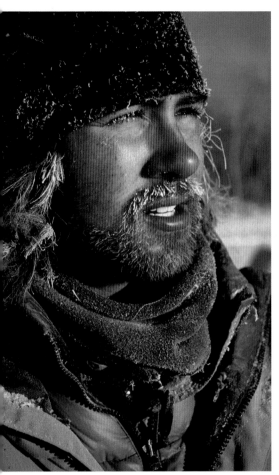

**FACES OF COLD.** *Frosty fur of an Inuit breed of sled dog (below) and a human traveler at minus thirty-eight degrees F*

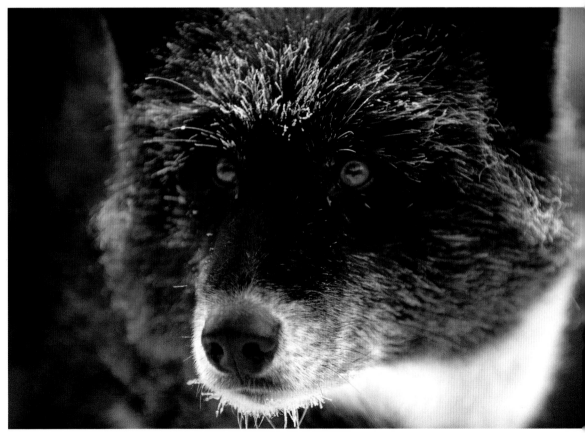

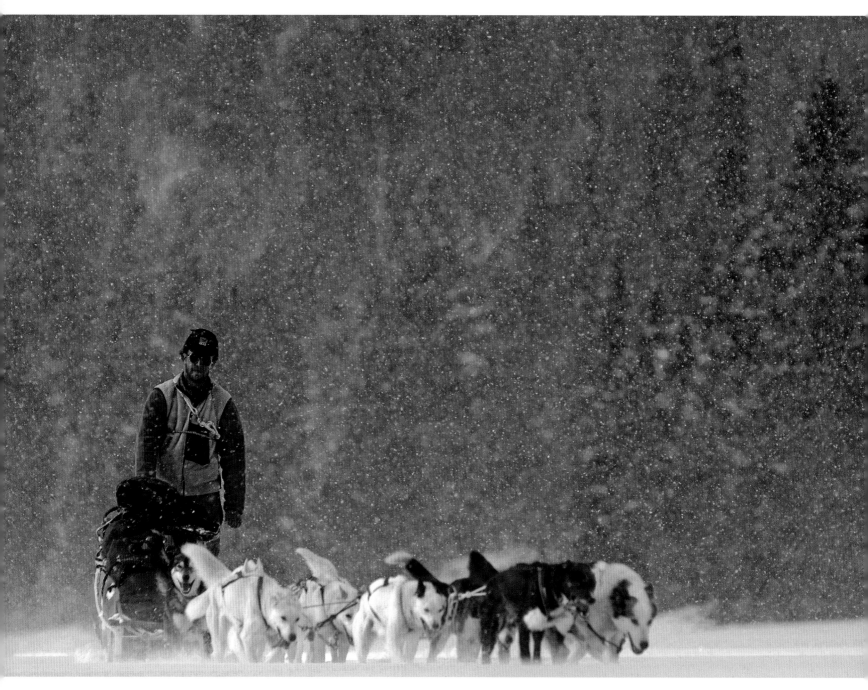

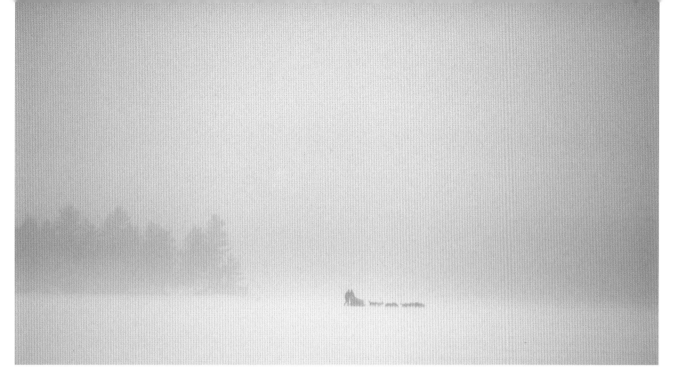

**BRED FOR COLD.** *Musher Odin Jorgenson (opposite) crossing a frozen Boundary Waters lake; dogsled on Moose Lake in a snowstorm (top); a midday nap for a Canadian Inuit dog; and two lead Alaskan huskies fly across Esther Lake in the eastern Boundary Waters.*

COLD-WEATHER PHENOMENA. *A sundog, or parhelion, a halo of sunlight refracted by ice crystals; a minimalist ice fisherman on Gunflint Lake; and a ladle of boiling water freezing in an explosion of ice crystals at minus thirty-eight degrees F*

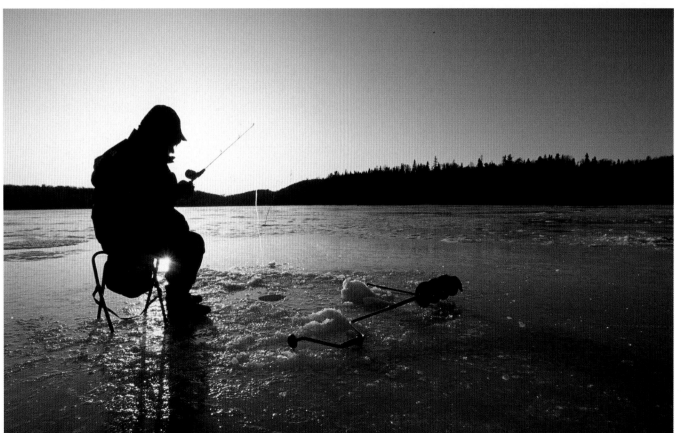

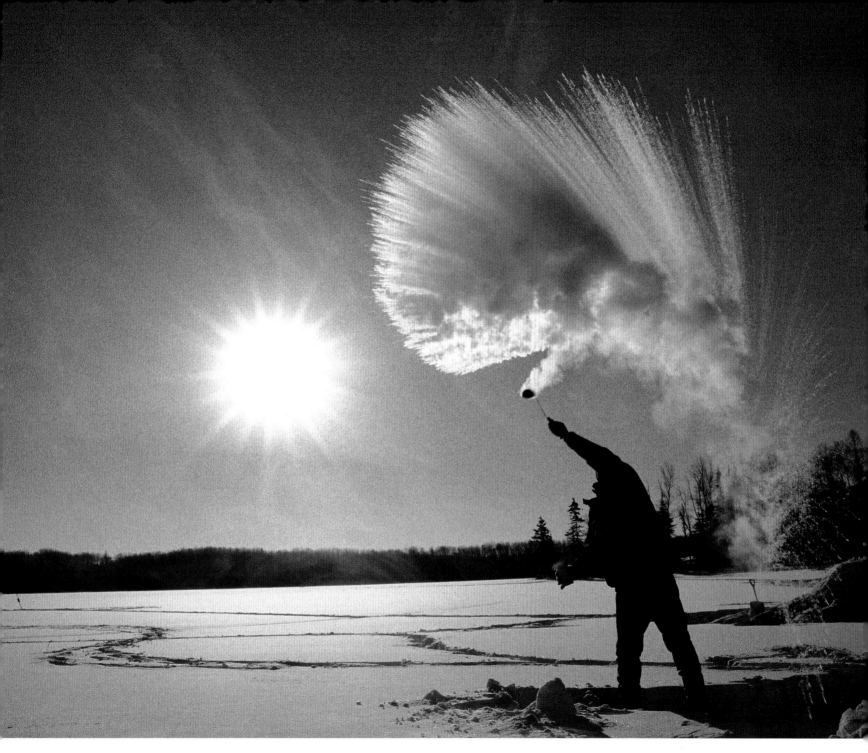

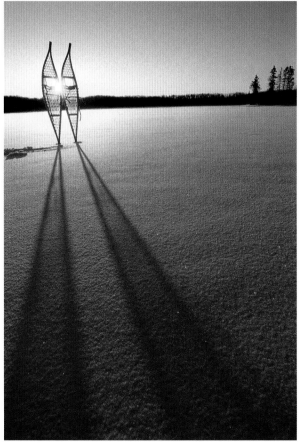

# adapted to cold

*The ranges of the closely related southern bobcat* and boreal lynx overlap in the canoe country wilderness. Bobcats appear to be expanding their range northward. Where the ranges meet, the two cats may hybridize, usually male bobcats breeding female lynx.

---

*Bobcats eat mostly cottontails and snowshoe hares* but also rodents and even deer (usually killed when resting). Snow depth as little as six inches begins to restrict their mobility. Lynx are longer legged with much larger feet. Lynx eat almost nothing but snowshoe hares. Because the hare population varies by ten-year cycles, so does that of lynx. The ups and downs were documented through Hudson's Bay Company trapping records dating back to the 1800s.

---

*Several northern species have their own snowshoes.* Canada lynx and snowshoe hare both have furry outsized paws to support their weight. Ruffed and spruce grouse grow "pectinations," fleshy combs along their toes, in fall and winter to help support their weight on snow. Grouse shed these growths in spring.

---

*Wintertime visitors to the Boundary Waters number* about 2,500, only 1 percent of the yearly total.

SNOW MOBILITY. *Snowshoeing at sunset (opposite), camping, and sunrise, all on the Kawishiwi River*

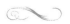 ICONIC FISH. *Anglers prize well-recognized symbols of the north, including lake trout, northern pike, and walleye.*

# IX ❧ SHADOWS OF THE NORTH

LAKE TROUT ARE LARGE FISH WITH OLIVE BACKS, SMALL LIGHT SPOTS, and pectoral fins with leading edges as white and crisp as the pressed collar of a newly laundered shirt. By rights, they are char—*Salvelinus namaycush*—related to arctic

char and brook trout. They are native to the lakes of the Canadian north and the coldest, deepest lakes of the Great Lakes and New England. Lake trout won't tolerate water warmer than about fifty-five degrees F. In summer they follow cool temperatures more than 100 feet deep, where they are nearly impossible to catch from a canoe. So instead, we had arrived in mid-May, when ice was off the lakes just two weeks. Snow lingered in the shadows of cliffs. Buds of aspen and birch were all but invisible. We wanted to fly-fish for these emblems of canoe country before they disappeared into deep water.

Lake trout are just one among many symbols of the north woods, common here but rare or absent farther south. The moose and Canada lynx are others, and even better known. They give real character to the northern forest—the moose by its occasional appearance and the lynx, a virtual shadow of the wilds, by its promise. Other

tokens of the boreal forest are the gray jay or "whiskey jack," which snatches tidbits from campers' larders, and the spruce grouse, a dark, portly bird known also as "fool's hen" for its naiveté.

These species are virtually unique to the north. Other creatures are found elsewhere but nonetheless give the boreal forest soulfulness and beauty. Who would recognize canoe country without the haunting cry of loons, the mournful howls of timber wolves, or the varied and expressive *quonks* of ravens? Would spring ever come to the north without the persistent call of the white-throated sparrow? How many fishermen paddle the border routes for no other reason than to catch a northern pike or walleye? Beaver, even though common far to the south, are a prime symbol of canoe country because their furs fed the trade that, as writer Eric W. Morse so poetically remarked, "unrolled the map of Canada."

If there is anything most characteristic of the north, it is the lakes themselves—clear and deep, set in the jagged core of the old continent, and rimmed by a forest of spruce, pine, and brilliant white birch. Overhead, on especially crisp, clear nights, the aurora borealis appears— shimmering curtains of lights, the Ojibwes' dancing of the dead on the trail of souls, a benediction of the north.

⟨⟩

SOME STRIKING SYMBOLS of canoe country have disappeared.

Woodland caribou, with their handsome coat and cream-colored collar, saucer-sized hooves, and sweeping antlers, roamed the border a century ago. Though not as numerous as moose, they were common enough to reinforce a symbolic connection between canoe country and the far north. In fact, *Atikokan*, the name of the Canadian town on the northern edge of the Quetico, is an Ojibwe word meaning "caribou bones." But logging, settlement, and more recently a warming climate have changed the forest to the benefit of white-tailed deer and the eradication of caribou.

Another vanished symbol of the far north is the relentless wolverine. Perhaps no animal, at least in the human imagination, has combined a more comic physique with a more ferocious character. Once trapped on occasion in northern Minnesota, the wolverine is rarely found along the border today.

This country has seen a long history of north-ward retreat. During the last ice age, until a bit more than 10,000 years ago, the land was piled high with glaciers. The ice shrunk away to the northeast. Glacial Lake Agassiz drained to reveal a scarred landscape of bulldozed bedrock, transported boulders, eskers (snak-ing ridges of sand), and mountains of gravelly glacial moraines. Tundra shrubs colonized the emergent land. Boreal spruce followed. The animals of this new land were symbols of a world soon to disappear forever— mammoths, mastodons, camels, horses, giant bison, and saber-toothed cats. These mega-creatures soon vanished, perhaps even as glaciers still covered the Quetico. Musk oxen retreated to the far north. Herds of barren-ground caribou gave way to woodland caribou.

Millennia marched by. The climate warmed. Jack and red pine flourished. Oak savanna and prairie crept to

the edge of canoe country. The climate cooled, and white pine appeared. Woodland caribou departed, replaced by moose and white-tailed deer.

～

IN PURSUIT OF OUR TROUT, we traversed a series of portages through potholes and small lakes. By coincidence, the route followed the boundary of two recent fires. As a result, we traveled through a Janus-faced forest: on one side, green pine, spruce, fir, and cedar; on the other, scorched rock, blackened sticks of spruce, and charred, twisted trunks of ancient pine.

The bristling stubble of aspen and birch that springs up after fire is prime browse for deer and moose. Indeed, the word *moose* derives from the Algonquin "twig eater." And sure enough, at the end of a portage, after an exhausting climb over a mountain of rock, we found a young bull moose. We had been chattering back and forth, but there it was, as though it didn't mind or were profoundly deaf. My friend Dave Garron began taking photos from twenty feet away. I chose to stay twenty feet behind Dave. I got photos of Dave taking photos. If the

moose turned ornery, Dave would provide a barrier—and give me some spectacular shots besides.

Years ago, seeing a moose was purely a thrill. And we saw them often. We found them browsing on the portages, lunching on water weeds along the shores of boggy creeks, even swimming across lakes, where we were tempted but never dared to paddle alongside and leap from the canoe to ride bareback as far as shallow water.

It's harder to find a moose now. Scientists have documented a slow decline in moose around canoe country. In recent years, emaciated but otherwise healthy-looking animals have simply keeled over. So inexplicable and spontaneous are their deaths that researchers call them *tipovers*. Puzzled scientists suspect ailments from brainworm to heat stress. So when I see a moose now, the thrill is tempered by some anxiety. It is difficult to imagine this country without moose.

These thoughts pestered me as we fished. We cast streamers and small lures without much success until the second evening, when we drifted in a light breeze along a rocky point. There I caught two trout, one nineteen inches and the other seventeen, in quick succession. With each, a sharp jolt ran up the fly line. The fight was strong and dogged, though

TOWERING RED PINE *grow throughout the Great Lakes region, characteristic of the border between the northern hardwood forest and the boreal spruce forest of northern Canada.*

neither fish made a long run or broke surface. In appearance, each was subdued but beautiful, the color of a general's uniform—drab olive with deep brass buttons and crisp white stripes. The strength of the north ran through their quivering muscles. We lopped off their heads, slit their bellies, and fried them whole, with butter, shallots, and parsley.

It may be that a hundred years from now, canoeists will not be able to catch lake trout here, that even the deepest lakes will have warmed sufficiently that trout will have joined a northward procession of caribou and lynx and other boreal creatures and plants. Such a loss would be a tragedy to those of us who know canoe country as it is. But it would be wrong to take this sentiment, and the anger and despair it provokes, too far. For icons are the things we seize upon to fix a place in our minds, but they are changeable and illusory. In some distant future, there will still be a tumult of life, a robust mix of species in the north. The people of that time will celebrate new icons—no longer moose, lynx, and spruce, but white-tailed deer, bobcat, and red maple. And there will remain a few of the old familiar signs, if we from the past were there to appreciate them— the lakes, the rocks, and the glimmering, shifting lights on the trail of souls. ❧

## boreal beasts

*Woodland caribou are disappearing from southern* Canada because of a complex interaction with moose, white-tailed deer, and wolves, says Canadian wildlife ecologist A. T. Bergerud. Caribou calve on remote islands and shorelines where wolves are unlikely to find the young. When moose or deer move into a region (because of warmer climate or increased logging or fire), wolves follow and thrive at numbers too great for caribou calves to survive. Moreover, the brainworm that infests deer kills caribou.

---

*Elk lived in much of Ontario, including Quetico, but* vanished from the province by the early 1800s.

---

*Minnesota's record northern pike—45 pounds,* 12 ounces—was caught in Basswood Lake in 1929. The state's record walleye, 17.5 pounds, came from the Seagull River in 1979.

---

*The Boundary Waters and Quetico provide fine fishing* for smallmouth bass, but the species isn't native to the area. They may have been introduced in the late 1930s. In 1942, Ely outfitters stocked smallmouth shipped by rail from Wisconsin in Crooked, Lac la Croix, and Basswood lakes. By the 1960s, they were common in more than 150 lakes throughout Quetico.

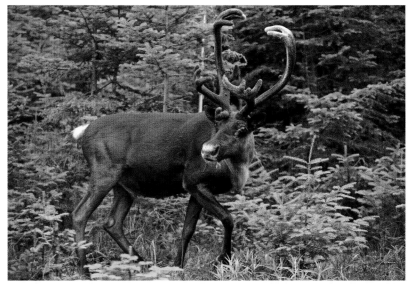

**A CHANGING CAST.** *Woodland caribou (right, on Lake Superior's Slate Islands), once common in border country, have retreated northward as the forest has become more suitable for moose and white-tailed deer. The iconic moose, with palmate antlers it sheds annually (opposite), may also be in decline.*

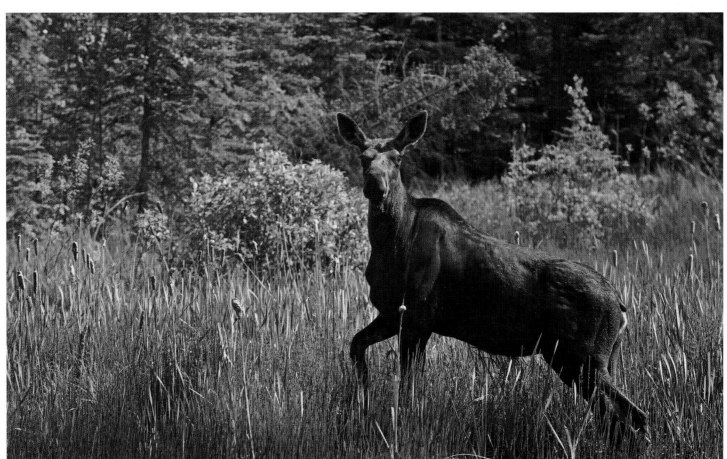

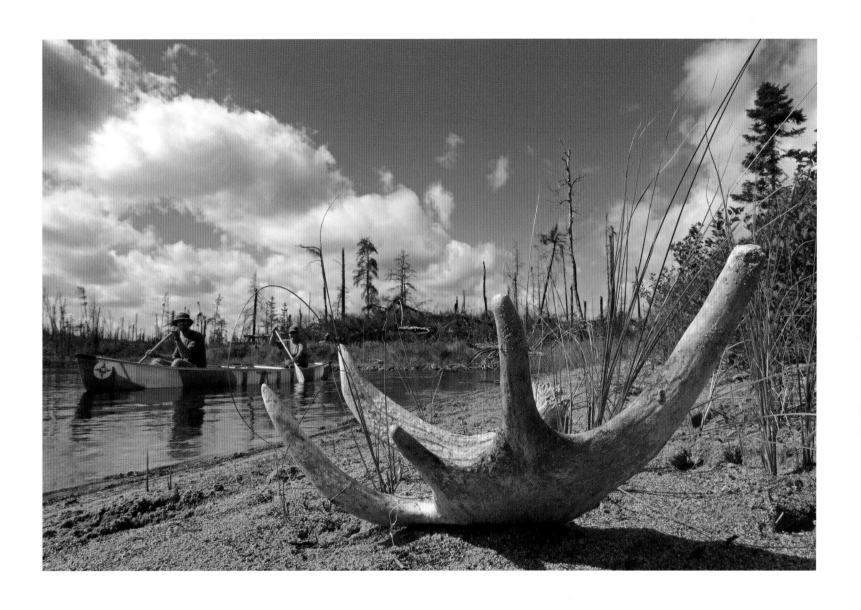

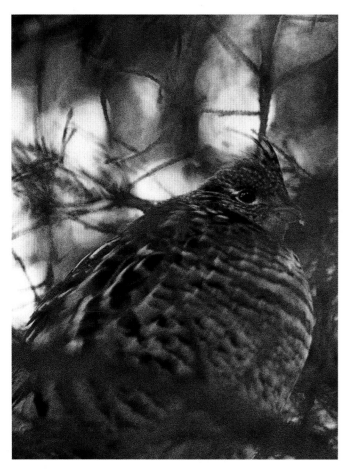

SNOW BIRDS. *Ruffed grouse (left) dive into snow to survive winter nights. Gray jay (above), bold relative of the more familiar blue jay, is a common denizen of coniferous forests.*

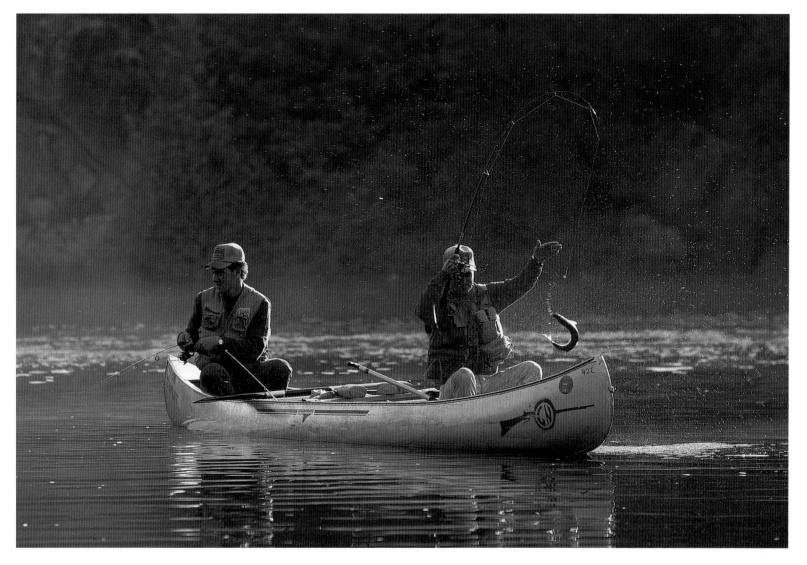

**HOOKED ONE.** *An angler lands a northern pike on the Granite River system between Gunflint and Saganaga lakes.*

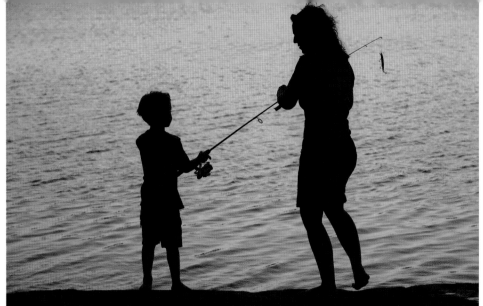

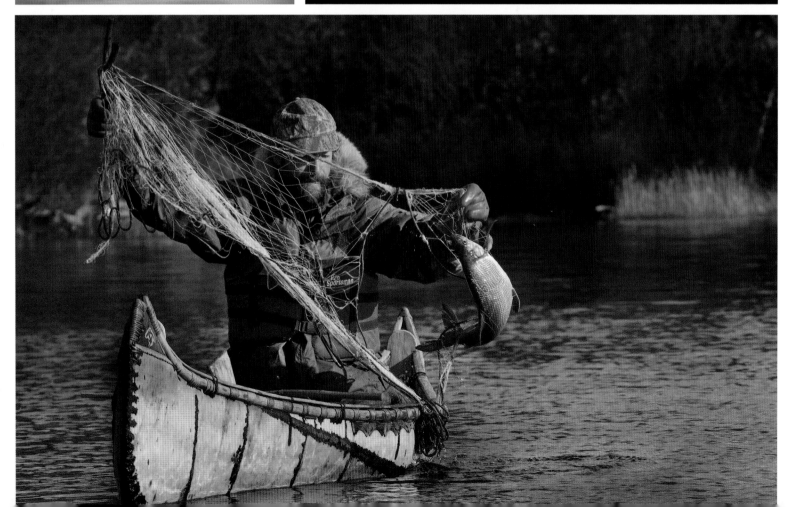

FISHERMEN, ALL. *Fall brings tullibee, normally residing in cool deep water, to spawn in the shallows, where fishermen can net them. The common merganser (far left) is a tireless fisher of northern lakes. Learning to fish (left), and Shade Lake, Quetico.*

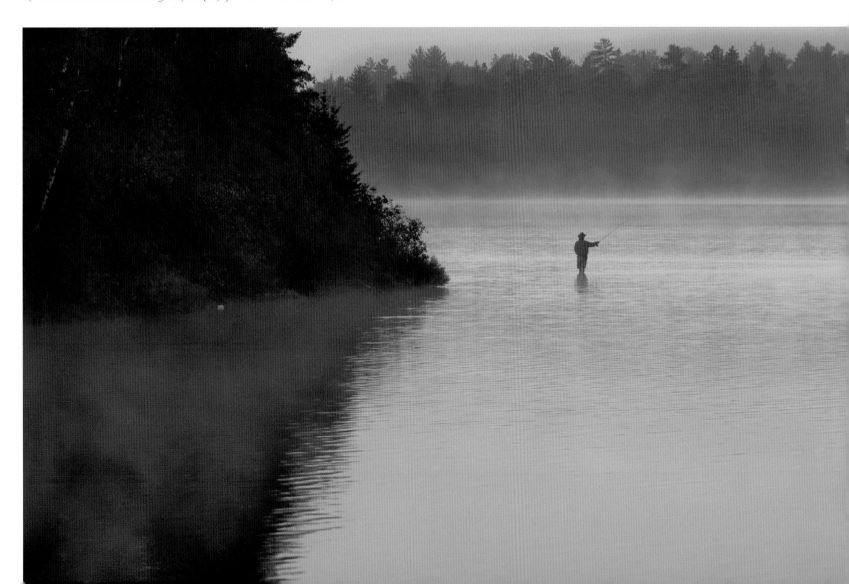

 LISTENING POINT, *Sigurd Olson's cabin on Burntside Lake*

# X ⚬ LISTENING POINT

MANY PEOPLE BELIEVE THAT PRESERVATIONIST Sigurd Olson wrote at his retreat on Burntside Lake. In fact, he usually attended to that chore back in Ely. At his cabin, a structure of hand-hewn logs as rustic as the greenstone beneath it, he was preoccupied

with fishing, canoeing, observing, and just thinking. He would walk to the end of the island point and watch the sunset as a loon's last call echoed over the water. As he wrote, "I named this place Listening Point because only when one comes to listen, only when one is aware and still, can things be seen and heard."

Probably more than any other single person, Olson was responsible for etching canoe country in the popular imagination and winning federal restrictions on logging and motor use for the Boundary Waters. Books such as *Listening Point* and *The Singing Wilderness* conveyed the romance of traveling in the tracks of Indians and voyageurs and provided a compelling philosophical and aesthetic argument for setting aside the area as wilderness.

As a young man, Olson took up the fight to keep dams and roads out of the Quetico-Superior. He was a wilderness ecologist for the Izaak Walton League of America and led the National Parks Association. While president of the Wilderness Society he helped to draft the federal Wilderness Act of 1964, which famously defined wilderness as "an area where the earth and its community of life are untrammeled by man, where man himself is a visitor who does not remain."

When I reread Olson's essays recently, I enjoyed them immensely. I admired his broad travels, his recollection of detail, and his joyful and romantic meditations on the north woods. To Olson, wilderness was a never-failing tonic for the ailments of civilization, a secure refuge from corrosive modernity.

Olson wrote his books as a man in need of refreshment, who drinks deep of the wilderness elixir but then, as a visitor, does not remain. He himself returned to Ely. There he knew miners and loggers. He knew Indians and backwoods whites who lived in the wilderness much of the year

fishing, hunting, and trapping. He knew a history of the border country inseparable from the people who had lived there for thousands of years. The wilderness, while wild, beautiful, natural, and inspiring, was not untrammeled. Olson knew a more complicated story than he was telling.

In Olson's beguiling portrait of canoe country, he paddles and portages the trails blazed long ago by people who mysteriously disappeared and left a lonely, uninhabited land for later visitors to enjoy, as though wilderness is populated by spirits but not by humans themselves. This idea of wilderness as pure, unpeopled Nature sprang from Romantic idealists and Henry David Thoreau. It "appealed to those bored or disgusted with man and his works," writes historian Roderick Nash, not only offering an escape from society but also "a stage for the Romantic individual to exercise the cult that he frequently made of his own soul . . . a perfect setting for either melancholy or exultation."

This conceit of wilderness collides with reality. "There is nothing natural about the concept of wilderness," writes historian William Cronon. "It is entirely a creation of the culture that holds it dear . . . a flight from history."

To create such a place of meditation and worship, the architects of "wilderness" had to overlook some inconvenient facts—especially the existence of people on nearly every habitable acre of the continent. In the case of the Boundary Waters–Quetico, these included colorful old-time settlers such as "Root Beer Lady" Dorothy Molter on Knife Lake and woodsman Benny Ambrose on nearby Ottertrack. More profoundly, indigenous people had lived in the wilderness and influenced it since canoe country emerged from the Ice Age.

Indians were inconvenient not only to the romantic view but also to the nationalist one. National parks were designated before the dust of Indian wars had settled, with ink still wet on Indian treaties. It was morally convenient to think of these lands as untrammeled, as though the original inhabitants never existed. This view was facilitated by outbreaks of disease. An estimated two-thirds to 90 percent of the New World inhabitants died from smallpox and other illness. Europeans explored a newly deserted land. In fact, recent research suggests Native Americans had numbered in the tens of millions. They hunted, fished, and built cities. They managed land and wildlife through fire.

To return the north country to a time when man was "a visitor who does not remain," then, is to create a place that never existed. As Cronon observes, such a view

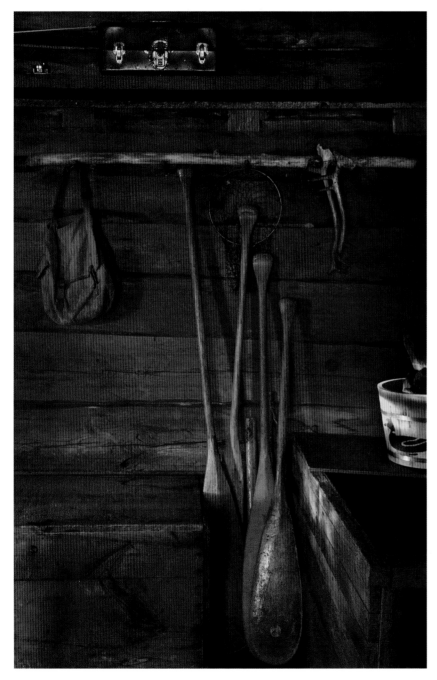

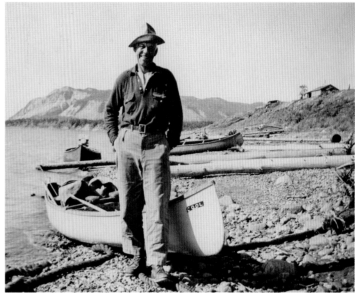

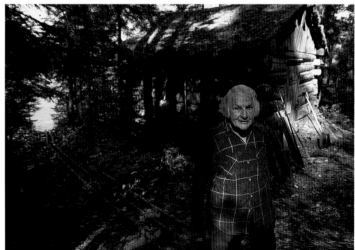

**WILDERNESS PERSONALITIES.** *Sig Olson (top) found solace at his Burntside retreat (left), preserved now by the Listening Point Foundation, and on long canoe voyages to the Canadian north. Dorothy Molter, last year-round resident of the Boundary Waters, stands by her icehouse, where even in October a remnant of the previous winter's ice harvest remains.*

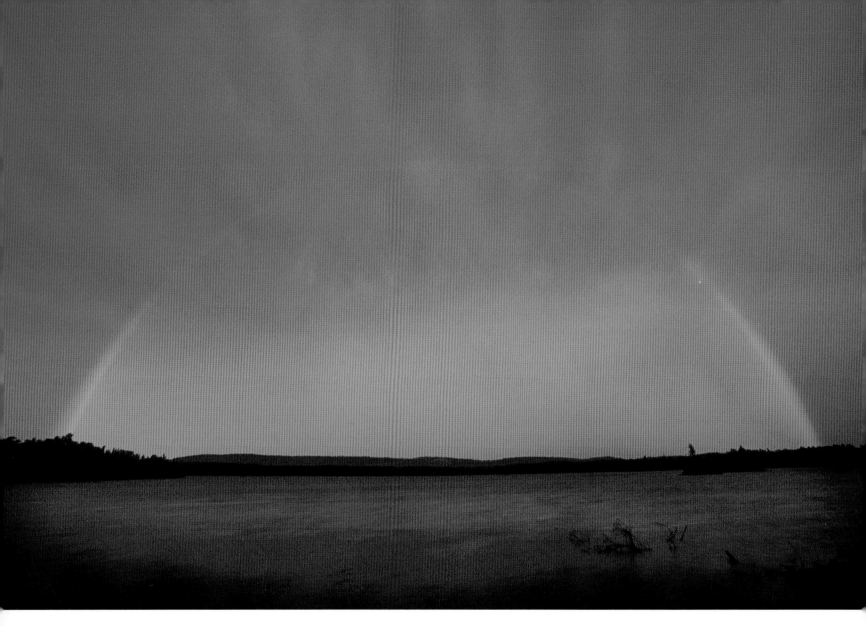

CLEARING SKIES. *Thunderstorm passes over Phoebe Lake, near the Sawbill Trail.*

of nature "embodies a dualistic vision in which the human is entirely outside the natural."

On the shore of Basswood Lake, a monumental outcrop rises more than a hundred feet above the water. If you had tramped the hilltop fifty years ago, you might have found dilapidated remains of low wooden houses sheltering Ojibwe graves. Even then they showed the ravages of time and vandalism. Today you'd find nothing at all, unless perhaps you were a trained archaeologist or were guided by the memory of having been to the place long ago. The view is impressive, nonetheless, looking down a vast body of water as beautiful as any along the border. Here are the traces of a people who lived in canoe country by the scores or hundreds—hunting, fishing, and harvesting wild rice. They were not mere visitors; they had every intention to remain.

"A forest is not a place to visit," said the chief of the nearby Lac la Croix Ojibwe, whose relatives and ancestors lived on these lakes. "It's a place to live."

⌇

RECENTLY, MY WIFE, SUSAN, AND I entered the Quetico and stopped at the ranger station on Beaverhouse Lake. We met Kelly Ottertail and his wife, Laura Menson, who both lived most of the year on the Lac la Croix reservation, a community of about 300 wedged between the Quetico and Boundary Waters. In recent years, the band has hammered out a program of cooperative management with the province. Band members staff ranger stations at Beaverhouse and on the reservation itself. They have also exercised rights to hunt and fish the Quetico and surrounding area, including an agreement to fly fishing clients into remote lakes and use small motors on fishing boats.

In fall, Ottertail said, he and other men on the reservation would hunt white-tailed deer. In winter he'd snowmobile to a cabin on Quetico Lake to trap fishers, otters, marten, and beaver. In spring Lac la Croix members would spear sturgeon forging up the Namakan River to spawn.

A century ago, many of Ottertail's ancestors lived on Kawa Bay on Kawnipi Lake. (He pronounced it *Ka-wa-ni-pi*.) Park officials say their records show the population of the Quetico community dwindled until it was no longer viable. But stories passed down in the community itself, says Ottertail, describe people being forced at gunpoint to move to other reservations after the area was set aside as a park. "They took them away,"

Ottertail said. "It was a military action, you could call it. That's what the elders told us." Then Ottertail looked over my map and marked several spots where we might catch walleye and lake trout.

Later Susan and I drove the long logging road to the Lac la Croix community. I wanted to talk to band members about the creation of the park a century ago. We had planned this trip for weeks, but all our attempts to reach anyone by phone or e-mail had failed. Was this subject still too touchy? The level of distrust still too great? We wondered at the reception we'd get—indeed, whether we'd be run out of town.

Town turned out to be a weedy spot with several dozen modern ramblers. We hoped to grab a bite, but the only restaurant was shuttered. I asked around for Leon Jourdain, the tribal chief and one of the few names I knew.

"They're at the round house."

In a circular log structure built for meetings and ceremonies, we found Jourdain, dressed in a fancy-ribbon shirt. "Did you eat yet?" he asked. As Susan and I dug into a buffet of walleye fillets, corn, and baked beans, Jourdain occupied the center of the building. A skylight illuminated his flowing white hair. The meeting had been called to discuss the tribe's plan to build a dam and ten-megawatt hydroelectric plant on the Namakan River at High Falls and Hay Rapids, just outside Quetico. Fewer than a dozen people listened as Jourdain spoke, switching between English and Ojibwe. At times he talked about the treaty establishing the band's right of occupancy, and his exhortations sounded like a sermon.

After the meeting, we sat down to talk and smoke. Jourdain told me much the same story Kelly Ottertail had: Confining people to tiny reservations "prevented them from hunting and fishing to provide for their families, to continue a way of life that has always existed here." When Ojibwe began hunting in the newly created Quetico, "they were chased all over the park by game wardens," some with dogs. One man hid under the ice overhanging a river. Jourdain said his father was caught with beaver hides and jailed for eight months. The last of the Kawa Bay residents were moved to surrounding reservations, including Lac la Croix, about 1930. "It was like a police force coming in and removing people from their homeland."

The hydro project, he explained, was an attempt "to step out of the box of programs and handouts from

FALL COLOR *shimmers in Superior National Forest.*

the government and create an economy that's going to be sustainable for our grandchildren. By the grace of the creator we found someone who said, 'I will finance this and I will hand over the keys in twelve to fifteen years.' We will have 100 percent ownership." The tribe will have a $40 million asset and be able to sell $2 to $3 million-worth of power a year.

The Lac la Croix community had met opposition from local groups, not least from environmental organizations. "I think part of what plays into this is that a First Nation is actually going to own a huge asset," Jourdain said. I thought, but didn't say, that environmentalists must be flummoxed that Indians would choose to dam a river. Indigenous people are always upsetting our liberal sensibilities.

"We're not saying we're not subject to environmental screening or any of that stuff," Jourdain said. "Sure we are." In fact, members of the band were working with Ontario wildlife biologists to radio-tag and track sturgeon to determine if they ascend the falls and rapids now, and if the dam should include a fish ladder.

"We're very, very cautious in displacing or defacing the natural beauty of the falls," Jourdain said. "We're a very traditional community. We believe the rapids, the falls, has a spirit. That spirit is living in this falls. And if we do any great damage to this falls in terms of displacing it to any great magnitude, that spirit will leave. And if our falls becomes spiritless, we become spiritless."

And then he added something that startled me for its bluntness: "There isn't anything environmentalists can teach us about environment.

"The spirits of our people are still in that park." He nearly spit out his words. "This arrogant, disrespectful thinking that this land is without people! Do you honestly believe there were no people in this part of the land? We'll tell you a different story. We still grieve for that land. Whether we're conscious of it or not, our spirit still grieves for that land. We will never let it go."

Whether to believe the benign account of park officials or the political narrative of the Lac la Croix was not my immediate concern. It was enough to know that Indians had lived in the "untrammeled wilderness" by the hundreds and to some extent still do. I might have considered Jourdain's rap on environmentalists a bit harsh. But as I thought about it, I came to see the Ojibwe have lived a life in which their role in nature is

sanctioned by practice, thought, and mythology. What would they learn from someone whose actions are guided by the belief he doesn't belong?

<center>∽</center>

FOR A HALF CENTURY, WE HAVE DRAWN borders around wilderness areas to repel the effects of human industry. Yet in the Boundary Waters–Quetico wilderness, moose seem to be growing scarce. Red maple are invading. Birch are dying. Ancient stands of pine are not regenerating. But because this is wilderness, we are at a loss to respond. As Cronon writes, we "leave ourselves little hope of discovering what an ethical, sustainable, honorable human place in nature might actually look like."

Exhibit One: the Boundary Waters wildfire policy. Forest fire has swept the border lakes for thousands of years. Lightning ignited some; Indians and settlers started others. In the twentieth century, Smokey Bear tried to snuff them out. In our modern wilderness, how much fire is "natural"?

Ecologists showed us that ground fires once groomed the magnificent stands of pine now over-grown with fire-vulnerable species and diseased and senescent stands of spruce and fir that are fuel for disastrous fires. So the U.S. Forest Service adopted a "let-burn" policy that seemed consistent with hands-off management of wilderness.

But officials couldn't "let burn" a fire too close to private property. Or when weather was windy or the forest tinder dry. And since fires were controlled in the surrounding forest, few or none would sweep in from outside the wilderness, as in times past. So "let burn" was really a "rarely burn" policy. And then the forest went up in an explosive, uncontrollable conflagration. A more natural regimen—measured against what had happened in the past—would be to prescribe burns throughout the forest. All unnatural, of course.

When I hiked though the remnants of the Cavity Lake and Ham Lake fires with ecologist Lee Frelich, he suggested the forest service should continue controlled burning, as it did after the big windstorm of 1999, and aggressively plant red and white pine to replace trees felled a century ago. But, Frelich says, the forest service "interprets the Wilderness Act very strictly and would consider this *manipulation* of the wilderness and not allowed."

UNNATURAL NATURE. *Warm temperatures, symptomatic of a changing climate, stress birches on thin soils and south-facing slopes. Red maple (right), vulnerable to deep winter cold, is spreading into canoe country.*

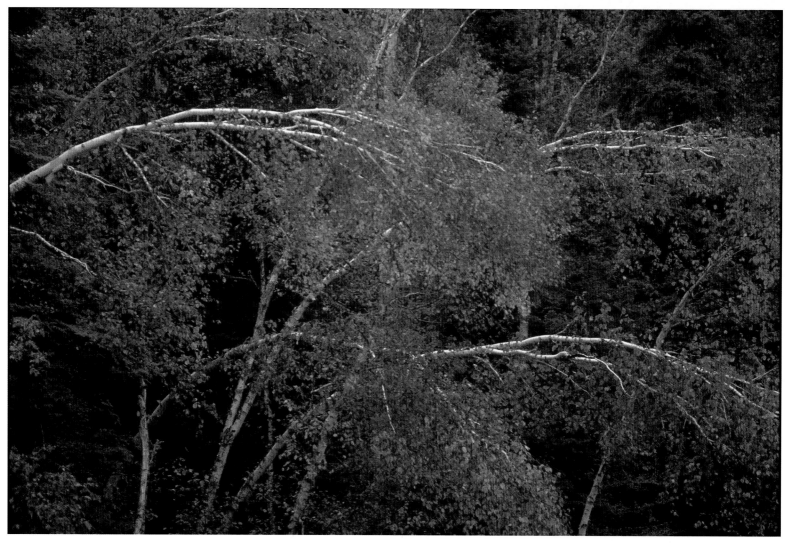

As I see it, a warmer future will justify more meddling in wilderness. What is the sense, after all, of pretending there is untrammeled nature in the face of human-caused climate change? If climate drives northern species from the Boundary Waters–Quetico, should the plants and animals adjust on their own, or should we "seed" them from elsewhere? If open barrens and oak savanna invade the forest, should we plant conifers? Or aid the conversion with controlled burns? If moose fare poorly, should we try to rescue them? Or stock elk instead? These are the sorts of questions forest managers are already beginning to ask. But if we hew to an earlier wilderness ideal, the answer will always be: We can't.

⁓

I AM A PRODUCT OF WESTERN man-versus-nature dualism and Romantic philosophers. My upbringing was split between the city and the woods. I'm a sucker for an uninhabited landscape, for its beauty in the absence of obvious human meddling, for its solitude and quiet, for its promise of simplicity and freedom. But I visit and then go home. So does nearly everyone who ventures into canoe country these days.

I recognize Sigurd Olson as the giant who fostered a love of canoe country, who protected it from the ravages of dams, mining, and unsustainable logging. Yet I think it's time to redefine wilderness to acknowledge the role of humans as part of nature. I am particularly drawn to words from a speech Olson made to the Sierra Club in 1965 (italics mine):

> I have discovered in a lifetime of traveling in primitive regions, a lifetime of seeing *people living in the wilderness and using it,* that there is a hard core of wilderness need in everyone, a core that makes its spiritual values a basic human necessity . . . Unless we can preserve places where the endless spiritual needs of man can be fulfilled and nourished, we will destroy our culture and ourselves.

In these words, there is no delusion we can circumscribe a border beyond which humans have no effect—or that we should. Wilderness is not really a place set apart. We are responsible for it just as we are for everything on this planet. To that extent, we do have dominion—whether we want it or not. ⁓

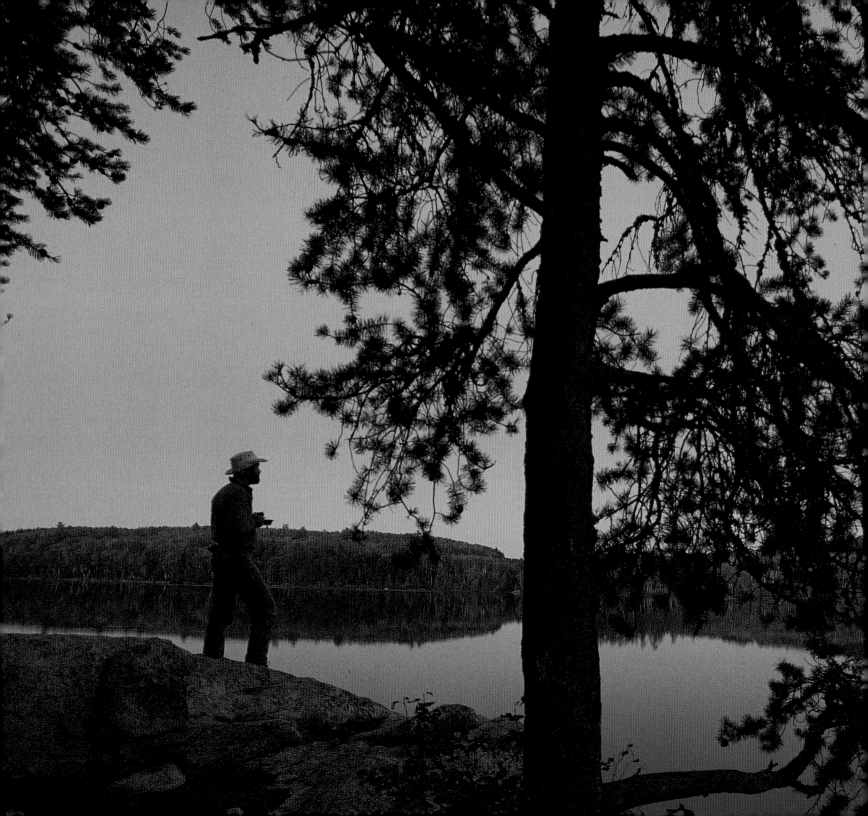

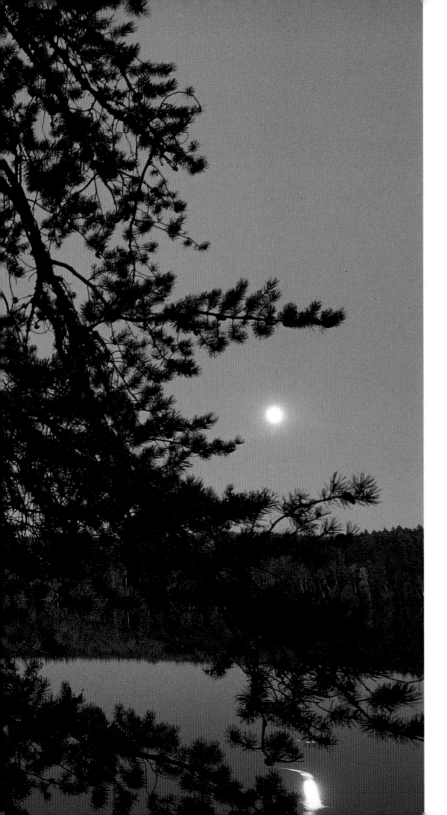

# the march of humanity

*Indians camped and hunted caribou in the Boundary* Waters–Quetico on the shores of glacial lakes perhaps 9,000 to 10,000 years ago, according to archaeologists. The environment and their settlement patterns suggest they used canoes of some kind.

---

*New technologies of the Woodland Period (3,000* years ago to historic times) included pottery, burial mounds, bow and arrow, and likely the bark canoe.

---

*The 1930 federal Shipstead-Newton-Nolan Act,* promoted by Ernest Oberholtzer, ended plans by industrialist E. W. Backus to build seven dams along the border lakes to provide hydropower for his paper mills.

---

*Protesters hung an effigy described both as author* Sigurd Olson and as forest ecologist Miron Heinselman in a 1977 congressional hearing in Ely over proposed restrictions on logging and motorized recreation in the Boundary Waters. Despite boos and catcalls, Olson testified that "this is the most beautiful lake country on the continent. We can afford to cherish and protect it."

---

*The 1978 Boundary Waters Canoe Area Wilderness* Act banned logging and mineral prospecting and mining and greatly limited motorboat and snowmobile traffic. Quetico became a wilderness park the same year.

MOONRISE, *Gneiss Lake, on the border near the Gunflint Trail*

# Author's Note

THANKS TO MY WIFE, Susan Kaneko Binkley, for her role in developing this book idea, for sharing the joys and toil of travel, and for sharpening the structure and reasoning in the essays.

Pamela McClanahan, director of the Minnesota Historical Society Press, provided wholehearted support for the book. Co-creator Layne Kennedy showed boundless energy in photographing canoe country.

Dave Garron and Jim Weseloh were eager canoeing companions. Adelaide and Marc Ackerson remained cheerful even as we portaged through knee-deep mud. The staff of Piragis Northwoods Company and Canoe Canada provided helpful advice on routes through the Boundary Waters and Quetico.

For informative conversations many years ago, I'd like to thank two giants of canoe country who have passed on, Bud Heinselman and Sigurd Olson.

Finally, I would like to acknowledge people and sources that provided information for individual essays:

"The Dream of a Canoe": Jeremy Ward, curator of the Canadian Canoe Museum, provided insights into the evolution of the canoe. Bill Clayton, archaeologist for the Superior National Forest, described early dugout-building sites. Erik Simula talked from the perspective of a present-day bark-canoe builder. Dave Hyink, known in his guiding days as "Pheasant," recalled details of wood-and-canvas canoes at Charles L. Sommers Wilderness Canoe Base. Background on bark canoes comes from the classic by Edwin Tappan Adney and Howard I. Chapelle, *The Bark Canoes and Skin Boats of North America* (Washington, DC: Smithsonian Institution, 1964).

"A Map in the Mind": For gender differences in navigating, see J. Dabbs, "Spatial Ability, Navigation Strategy, and Geographic Knowledge Among Men and Women," *Evolution and Human Behavior* 19.2 (1992). For information about Auchagah and his map, see Dictionary of Canadian Biography Online. George Nelson details the chaos and strife of the fur business in *My First Years in the Fur Trade: The Journals of 1802–1804,* eds. Laura Peers and Theresa Schenck (St. Paul: Minnesota Historical Society Press [hereafter, MHS Press], 2002). For the evolution of maps, see *The History of Cartography: Cartography in Prehistoric, Ancient and Medieval Europe and the Mediterranean*, Vol. 1, eds. J. B. Harley and David Woodward (Chicago: University of Chicago Press, 1987).

"Bones of the Earth": Of the many sources describing the origins of the "sublime," the most pertinent to the context of wilderness is Roderick Nash, *Wilderness and the American Mind* (New Haven: Yale University Press, 1967). For descriptions of geology and mining, see Richard W. Ojakangas and Charles L. Matsch, *Minnesota's Geology* (Minneapolis: University of Minnesota Press, 1982). Descriptions and discussion of the many pictographs in the area are found in Selwyn H. Dewdney and Kenneth E. Kidd, *Indian Rock Paintings of the Great Lakes* (Toronto: published for the Quetico Foundation by University of Toronto Press, 1962); Thor Conway, *Painted Dreams: Native American Rock Art* (Minocqua, WI: NorthWord Press, 1993); and Michael Furtman, *Magic on the Rocks: Canoe Country Pictographs* (Duluth, MN: Birch Portage Press, 2000).

"The Portage": The portage conventions and routes of the Boundary Waters–Quetico belong in the broad tradition described by Eric W. Morse, *Canoe Routes of the Voyageurs: The Geography and Logistics of the Canadian Fur Trade* (St. Paul: MHS Press, 1962). Other informative sources on the fur trade include Grace Lee Nute, *The Voyageur's Highway: Minnesota's Border Lake Land* (St. Paul: MHS Press, 1941); Carolyn Gilman, *Where Two Worlds Meet: The Great Lakes Fur Trade* (St. Paul: MHS Press, 1982); and Gilman, *The Grand Portage Story* (St. Paul: MHS Press, 1992).

"An Imaginary Line": Shirley Peruniak and Jon Nelson, retired naturalists for Quetico Provincial Park, extolled the virtues of the park, calling it "the wilder twin." An excellent description is Nelson's *Quetico: Near to Nature's Heart* (Toronto: Natural Heritage Books, 2009). Another good account, told from the Canadian perspective, is Bruce M. Litteljohn, *Quetico-Superior Country: Wilderness Highway to Wilderness Recreation*, reprinted from *Canadian Geographical Journal* (August–September 1965). Nute (above) and other chroniclers of the fur trade describe the mistaken assumptions involved in drawing the international border through canoe country.

"Forest Primeval": Interviews with forest ecologists Lee Frelich and the late Miron "Bud" Heinselman provided much of the material for this chapter. So did Heinselman's comprehensive *The Boundary Waters Wilderness Ecosystem* (Minneapolis: University of Minnesota Press, 1999).

"Winter Trials": *The Boundary Waters Wilderness Ecosystem* provides a general discussion of climate and plant and animal communities. So does John R. Tester,

*Minnesota's Natural Heritage: An Ecological Perspective* (Minneapolis: University of Minnesota Press, 1995).

"Shadows of the North": Contemplating the retreat of various boreal icons began with conversations with Lee Frelich, as well as a magazine story I wrote for *Minnesota Conservation Volunteer* titled "Moose Mystery" (September–October 2003). For an update on moose in Minnesota, see Gustave Axelson, "End of the Reign?" *Minnesota Conservation Volunteer* (July–August 2008).

"Listening Point": Leon Jourdain, Kelly Ottertail, and Laura Menson provided stories, commentary, and details about the Lac la Croix Ojibwe. The theoretical groundwork for this essay comes from William Cronon, "The Trouble with Wilderness; or, Getting Back to the Wrong Nature," in *Uncommon Ground: Rethinking the Human Place in Nature* (New York: W. W. Norton & Co., 1995). For more on the "depopulation" of America through disease and the vigorous management of the land by native populations, see William M. Denevan, "The Pristine Myth: The Landscape of the Americas in 1492," *Annals of the Association of American Geographers* 82.3 (1992). Peter Reich, forest ecologist at the University of Minnesota, introduced me to the concept of ecological resilience and the possibility of adapting a forest to changing climate.

Sidebars: In addition to the aforementioned sources, information for sidebars throughout the book came from Stephen Wilbers' excellent website of border country chronology (http://www.wilbers.com/ChronologyShort.htm). Valuable information on portaging and Grand Portage came from Alan R. Woolworth, *An Historical Study of the Grand Portage, Grand Portage National Monument, Minnesota* (St. Paul: MHS Press, 1993).

## Photographer's Note

DURING MY TIME AT THE UNIVERSITY of Minnesota–
Duluth, the facts of student life—no car and no mon-
ey—conspired to keep me pretty close to campus. Yet,
as a transplant from Alaska with an interest in untram-
meled places, inevitably I found the path to that regional
treasure, the Boundary Waters Canoe Area Wilderness.

    Like many adventures to storied places, my first
trip into the Boundary Waters was the most memorable.

Over-packed and full of gusto, a buddy and I were pre-
pared to paddle six lakes over seven days. On day one,
windy conditions and a brewing summer thunderstorm
slowed our progress. At the first portage, we decided to
drag our aluminum canoe through the shallow stream
running between the lakes rather than walk the 100 rods
with food-laden packs. Heck, we figured we'd portage on
the way out when we were much lighter.

The afternoon skies continued to darken, producing great light—the kind where sunshine bathes one shore and blackness overtakes the other. We found ourselves knee-deep in moving water holding a metal canoe when lightning struck a tree a mere fifteen yards away. The bright flash and explosive thunderclap were perfectly in sync. It wasn't the lightning but the thunder that sliced through my core. To this day, I cannot remember how we made our way to shore. Those seconds of terror I'll never get back. We sat huddled under trees watching the canoe, lodged on rocks in the middle of the stream, fill with rainwater. Then the storm cleared and sunny skies offered a brilliant, conciliatory rainbow.

As we paddled into the next lake, we spotted a loon effortlessly gliding across the water, moving toward one end of the rainbow that seemed to pour into the scene. It was a photographer's gift, the quintessential wilderness moment: a frame one waits a lifetime to witness, let alone be in position to capture. I grabbed my camera from the plastic bag in which I had carefully packed it. But the bag was nearly filled with water, and as I lifted my camera, hoping for a miracle, its body drained like a leaky tin can. Capturing that moment was not meant to be.

I wasn't angry about missing the image; I was taken in by the scene. It was a typical introductory episode for the inexperienced wilderness enthusiast. I accepted the damage to my gear and vowed to pack better next time.

Wilderness can expose your character in raw terms. What I love about the Boundary Waters–Quetico is that the region is approachable, yet wild: The decisions one makes here are often simple, yet significant. I learn as much about myself as I do about this pristine boreal forest we paddle through. I've made the journey annually for nearly thirty years.

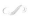

AS THE FINAL STAGE OF THIS BOOK PROJECT launched in late summer 2009, Will Powers, design and production manager at the Minnesota Historical Society Press, passed away unexpectedly. Will loved the northland, and thoughts of his artistic excellence danced in my head as I searched for appropriate images for this book. While photographing the Milky Way and Perseid meteor showers on Agnes Lake in the Boundary Waters a little more than a month after Will's passing, I felt his presence. Man, isn't that what life is all about? Connections to others; a joy in our surroundings. My wilderness experiences in the Boundary Waters–Quetico are dedicated to you, my friend.

# Index

*Page numbers in italic
refer to photographs*

## A

Abenaki Indians, 21
Adney, Edwin Tappan, 21
Agassiz, Glacial Lake, 10,
 49, 108
Agnes, Lake, *2–3*
Ainu people, 21
Alpine Lake fire, 84
Ambrose, Benny, 120
animals, 85, 97–98, 105,
 107–11, *112–16. See also
 individual species*
archaeology, 10–11, 25–26,
 37–38, 131. *See also*
 pictographs
Armin Lake, *63*
Askin, John, 76
aspens, 85, *93*, 109
Assiniboine Indians, 33
Athabasca, Lake, *63*
Atikokan, ON, 36–37, 108
Auchagah (Cree Indian), 24
aurora borealis, 108

## B

Backus, E. W., 131
balsam firs, 83, 84
bass, smallmouth, 111
Basswood Lake, *60, 63,*
 111, 123

Basswood River, 38
bears, black, *57,* 70, 76
Beaverhouse Lake, 1,
 5, 38, 123
beavers, *60,* 85, 107, 123
bedrock, 35, *46,* 49
Bergerud, A. T., 111
Big Fork, MN, *17*
Big Fork River, 11, 12
birch trees, 83, 84, *93,* 109,
 127, *128*
blueberries, 1, *4,* 83, *93*
bobcats, 97–98, 105, 111
Boessel, Ray, Jr., 12
Bonga, Stephen, *63*
border, U.S./Canada,
 65–70, 76
Boundary Waters Canoe
 Area Wilderness, 1, 5,
 37, 68–70, 131. *See also
 individual lakes*
Boy Scout camps, 14, 51
brainworm, 97, 109, 111
Brown, Ralph H., *59*
Burntside Lake, *vi, 118,*
 *119, 121*

## C

Camp Widjiwagan, *20*
campsites, 5, 26, 69–70, 74
Canadian Shield, 35, 36,
 *42–43,* 49
canoe country, 1–5,
 9–10, 84–85. *See also*

wilderness, concept of
canoes: aluminum, 9,
 14, *18, 20;* birch-bark,
 11–12, 13, *13, 16, 17,* 21,
 *63;* building, 11–14, *13,*
 *16, 17;* canvas, 13–14;
 dugouts, 10–11, *13;*
 famous, 14; fiberglass,
 9, *19;* Kevlar, 15, *19,*
 53, *56, 91;* loading and
 unloading, 51, *55;*
 moose hide, 21;
 north canoes, 52, *63;*
 repair, 13; Royalex, 15;
 wooden, 21
caribou, woodland, 108–9,
 111, *112*
Cavity Lake fire, 83–84, 127
cedar, northern white, 82,
 83, 84, *92*
Champlain, Samuel de, 21
Charles L. Sommers Wil-
 derness Canoe Base, 14
Chestnut Canoe Com-
 pany, 14
Cichanowski, Mike, *19*
Cirrus Lake, 70
climate change, 80–82,
 84–85, 108–9, 129
cold, 95–96, 97–98,
 *99, 103*
coniferous trees, 96
Conway, Thor, 25, 38
cooking, *4, 73, 74,* 76

Cree Indians, 24, 33
Cronon, William, 36,
 120–23, 127
Crooked Lake, *27,* 111

## D

dams, *60,* 124–27, 131
Darkey Lake, 38
Davis, George, 36
deciduous trees, 96
deer, 80, 84, 97,
 109, 111
Dene people, 24
Dennis, John, 36
diorite, *44*
dog sledding, 95, *99–101*
drought, 85
Duncan Lake, *39*

## E

E. M. White Canoe Com-
 pany, 14
Eagles Nest Island, 84
earthworms, 84
ecology, 79–85, 107–9,
 111, 126
economic concerns, 126
elk, 111
Ely, MN, 9, 14, 37, 111,
 119–20, 131
entry points, 5, 69, 76
environmentalism, 126–
 27. *See also* wilderness,
 concept of

Erdrich, Louise, 25
Esther Lake, *101*
exploration, 10, 12, 24, 33,
 36, 120

## F

fires: Ham Lake fire, 82–
 83, *86–89;* intentional
 burns, 69, 80, 83, 127;
 pictures, *86–91, 93;*
 role of, 79–80, 83–85,
 109; wildfire policy, 127
fireweed, 83, 84, *93*
firs, balsam, 83, 84
fish. *See individual species*
fishing: ice fishing, *102;*
 for lake trout, 107,
 109–11; by Ojibwe
 Indians, 68–69, 123;
 pictures, *106, 115, 116–17*
flowers, *57,* 83, 84
footwear, 51, *58*
forests, 79–85, 108–9,
 127, *128*
Fort Charlotte, 76
Fort Chipewyan, *63*
Fort Frances, 76
Fort William, 33
foxes, red, *89*
Frelich, Lee, 80–85,
 *86,* 127
Fries, Magnus, 79
fur trade, 12, 36, 52–53, *63,*
 76, 107

**G**

gabbro, 40
Garron, Dave, 109
geology, 10, 35–38, 49, 108
glaciers, 35, 49, 108
Global Positioning
    System (GPS), 25
global warming, 80–82,
    84–85, 108–9, 129
gneiss, 40, 46
Gneiss Lake, 4, 130–31
gold, 36–37
Gowan Lake, 22
Grand Marais, MN, 18
Grand Portage, MN,
    12–13, 16, 63, 65, 76
granite, 44, 46–47
Granite River, 44, 115
Grey Lake, 6, 42–43, 76–77
Groseilliers, Médard
    Chouart des, 33
grouse, 98, 105, 107, 114
Guide (E. M. White
    canoe), 14
Gunflint Lake, 24, 102
Gunflint Northwoods
    Outfitters, 18
Gunflint Trail, 80, 82, 88,
    91, 130–31
Gwich'in Indians, 11–12

**H**

Hafeman, Bill, 12, 17
Ham Lake fire, 82–83,
    86–89, 127
harebells, 57
Hay Rapids, 124
Hegman Lake, 38
Heinselman, Miron "Bud,"
    79–80, 131
High Falls, 124
Honeymoon Bluff, 49
Hudson's Bay Company,
    105
human role in nature, 36,
    37–38, 127, 129
Hungry Jack Lake, 49
hunting, 68, 123, 124
hydroelectric plant
    projects, 124–27, 131

**I**

Ice Age, 35, 49, 108
ice fishing, 102
Indians: canoes, 11–12, 13,
    13–14, 21; inhabiting
    canoe country, 33,
    120–28, 131;
    navigation, 23–24;
    as slaves, 76; and "wil-
    derness," 120–28
iron ore, 37
Iroquois Indians, 21

**J**

Jacobson, Cliff, 76
jays, 98, 107, 114
Jorgenson, Odin, 100
Jourdain, Leon, 124–28

**K**

Kahshahpiwi Lake, 39,
    66–67, 74
Kaministiquia River, 24, 33
Kawa Bay, 123–24
Kawishiwi River, 94, 104–5
Kawnipi Lake, 123–24
Kekekabic Trail, 10, 24
Kennedy, Layne, 82
Knife Lake, 24, 37, 120

**L**

La Vérendrye, Pierre
    Gaultier de Varennes,
    sieur de, 24
Lac la Croix (Lake):
    fishing in, 111;
    pictures, 7, 30, 34, 45, 75
Lac la Croix community,
    123, 124–27
Lac la Croix Guides As-
    sociation, 5, 123
Lac la Croix Ojibwe, 25,
    30–31, 68–69, 123–27
lake trout, 96, 107,
    109–11, 124
lakes, numbers of, 5
Laurentian Shield. See
    Canadian Shield
lichens, 46–47
lightning, 78, 83, 127
Little American Island, 36
Little Indian Sioux fire, 85
Little Indian Sioux River, 22
lob pines, 33
logging, 80, 82, 119, 131
loons, 4, 48, 71, 107
lynx, 97–98, 105, 107

**M**

Malberg Lake, 70
Malecite Indians, 11–12, 21
Maligne River, 23
maple trees, 84, 96, 111,
    127, 128
maps, 23–26, 28, 33
Maraboef Lake, 64
McKenzie Maps, 33
McPhee, John, 12
Menson, Laura, 123
mergansers, 116
meteor showers, 32–33, 75
Miles Island, 84
Milky Way, 32–33, 75
mining, 36–37, 131
Molter, Dorothy, 120, 121
Montreal canoe, 21
Mookomaan Zaaga'igan.
    See Knife Lake
moose, 84, 97, 107, 109,
    112–13, 127
Moose Lake, 101
Moose River, 56
Morse, Eric W., 107
mosquitoes, 49, 52
motor use in parks, 5, 119, 131

**N**

Namakan River, 11, 24,
    123, 124
Nash, Roderick, 120
national parks, 120
nature, man's relationship
    to, 36, 37–38, 127, 129
navigation, 10–11, 12,
    23–26, 33, 52
Nelson, George, 23
Nelson, Jon, 69
Nina Moose Lake, 4,
    32–33, 41, 62
Nina Moose River, 27, 54
non-native species, 111
north canoes, 21
North West Company,
    13, 33
Noyon, Jacques de, 33

**O**

oak trees, 84, 108–9
Oberholtzer, Ernest, 131
Ogishkemuncie Lake, 24
Ojibwe Indians: canoes,
    11–12, 13; habitation
    of border area, 33;
    hunting by, 123, 124;
    Lac la Croix, 25,
    30–31, 68–69, 123–27;
    navigation, 23–24;
    pictographs, 25, 30–31;
    and rock, 37–38; and
    "wilderness," 123–28

Olson, Sigurd: Burnstside Lake cabin, *118, 121;* preservation efforts, 119–20, 129, 131; writings, 26, 53
Ontario Parks, 5
Ottertail, Kelly, 123–24
Ottertrack Lake, 120

P

packing, 51–52, *54*
parhelions, *102*
Paris, Treaty of, 65
Paulson Mine, 37
peat bogs, 96
Pelly, David, 24
Perseids, *32–33, 75*
Peter Joe (Malecite Indian), 21
Phoebe Lake, *122*
pictographs, 25–26, *30–31,* 38
Pigeon River, 65–68, 76
pike, northern, 107, 111, *115*
pine trees: jack pine, 84, 85, 108; lob pines, 33; red pine, 83, 84, 108, *110,* 127; white pine, 82, 84, 109, 127
Pioneer Mine, 37
portages, *16, 50,* 51–53, *54–56,* *58–63,* 63

preservation of wilderness, 68, 119–20
Prospector (Chestnut canoe), 14

Q

quartz, 36, *46*
Quetico Lake, 38, 70
Quetico Provincial Park, 1, 5, 68–70, 131. *See also individual lakes*

R

Radisson, Pierre-Esprit, 33
Rainy Lake, 33, 36, 68
Rainy Lake City, 36
Rainy River, 11
remote border-crossing permits, 69, 76
rock, 35–38, *40, 46,* 49
rock paintings, 25–26, *30–31,* 38
Romanticism, 36, 120
Rose Lake, *39*
Roy Lake fire, 83

S

Saganaga Lake, *8,* 24, 38, *40,* 49
St. Louis River, 12
Saturday Bay, 27
Sawbill Trail, *122*
Seagull Lake, 80, 82–83, *88*
Seagull River, 82, 111

Seliga, Joe, 14
Shade Lake, *46, 117*
Shipstead-Newton-Nolan Act, 131
Simula, Erik, 12–13, *16*
skiing, 95
Slate Islands, *112*
slaves, 76
snow, *94,* 96, 97–98, *100–105*
snowshoe hare, 97, 105
snowshoeing, 95, *104*
soil, *47,* 49, 96
sparrows, 83, 85, 107
spiritual geography, 25–26, 38, 126
spruce trees, 84, 108
squirrels, 98
Stairway Portage, *39*
striations, 49
sturgeon, 123, 126
Sturgeon Lake, 24
sublime, the, 36, 38
Sue Falls, 70
sundogs, *102*
Superior, Lake, 13, 63, 65–68, *112*
Superior National Forest, 5, 68, *125*
Superior-North Canoe Outfitters, *91*

T

Tanner, John, 23

Tanner's Rapids, 23
Thompson, David, 33
Thoreau, Henry David, 120
Three Mile Island, 80, 82–83
Thunder Bay, ON, 24
treaties, 65–68
trees, 79–85, 108–9, 127, *128. See also individual species*
trout, lake, 96, 107, 109–11, 124
tullibee, *116*
tumplines, *16*

U

U.S. Forest Service, 5, 127

V

Vaillancourt, Henri, 12
Vermilion Iron Range, 37
Vermilion River, 36
Voyageur Maps, 33
voyageurs, 21, 33, 52–53, 63
Voyageurs National Park, 1, 85

W

W. A. Fisher Maps and Publications, 33
walleye, 107, 111, 124
Ward, Jeremy, 12

water, clarity of, 96
water filtration, *72*
Webster-Ashburton Treaty of 1842, 65–68
Wenonah Canoe, 19
West Lake, *55*
Wet Lake, *75*
wilderness, concept of, 5, 68, 119–23, 126–27, 129
Wilderness Act of 1964, 119
Wilderness Canoe Base camp, 82
windstorms, 80–82, *81,* 83
winter, 95–105
wolverines, 108
wolves, 97, 107
Woodland Period, 131

Y

Yakut people, 21
YMCA camps, 14
YWCA campers, 20
Yum Yum Lake, *63*